studio photography

Essential Skills

studio photography

john child

Focal Press

OXFORD AUCKLAND BOSTON JOHANNESBURG MELBOURNE NEW DELHI

Focal Press
An imprint of Butterworth-Heinemann
Linacre House, Jordan Hill, Oxford OX2 8DP
225 Wildwood Avenue, Woburn, MA 01801-2041
A division of Reed Educational and Professional Publishing Ltd

 A member of the Reed Elsevier plc group

First published 1999

© John Child 1999

British Library Cataloguing in Publication Data
A catalogue record for this book is available from the British Library

Library of Congress Cataloguing in Publication Data
A catalogue record for this book is available from the Library of Congress

ISBN 0 240 51550 1

Printed and bound in Great Britain

FOR EVERY TITLE THAT WE PUBLISH, BUTTERWORTH-HEINEMANN
WILL PAY FOR BTCV TO PLANT AND CARE FOR A TREE.

AYLESBURY COLLEGE

LIBRARY

Acknowledgements

Among the many people who have helped make this book possible, I wish to express my thanks to the following individuals:

- ~ Professor Robin Williams and Michael Wennrich for their strong support for the project.
- ~ Mark Galer, Roy Cushan and Gunter Bohensky for their help, advice and input to the final copy.
- ~ The students of RMIT University, Melbourne for their illustrative input, enthusiasm and friendship.
- ~ And to Gloria and my family for their encouragement and understanding throughout my photographic career, thank-you.

Picture credits

Cover: Gus van der Hyde

p.1 Thuy Vuy, Chloe Paul; p.4 Hugh Peachey, Imogen Barlow; p.5 Joanne Gamvros; p.6 Tommy Tang; p.7 Viva Partos; p.8 Julia Margaret Cameron, Liam Handasyde; p.9 Michael Wennrich; p.11 Thuy Vuy, Gary Gross; p.12 Lachlan Bailey; p.13 Antonius Ismael; p.14 Laura Humphryis; p.15 Johanna McCubbin; p.17 Les Horvat, Imogen Barlow; p.18 Gary Gross; p.19 Karen Trist; p.20 Tetsuhara Kubota, Terence Langendoen; p.22 Hugh Peachey; p.25 Ivan Shokal; p.27 Michael Davies; p.30 David Peakal; p.34 Joshua Poole; p.36 Charanjeet Wadhwa, Soek Jin Lee; p.40 Johanna McCubbin, Samantha Souter; p.41 Sabina Bukowski, Adam Howden; p.43 Jens Waldenmaier, Johanna McCubbin, Erik Soh; p.44 Antonius Ismael, Saville Coble; p.47 Tori Costello, Marcus Ferraro; p.49 Michael Wennrich; p.50 Jana Liebenstein; p.52 Dianna Snape, Jana Liebenstein; p.57 Kate Beadle, Michael Davies, Charanjeet Wadhwa, Soek Jin Lee; p.58 Hugh Peachey, Chloe Paul, Tejal Shah; p.59 Tejal Shah; p.60 Arthur Sikiotis, Hugh Peachey; p.62 Hugh Peachey, Tetsuhara Kubota; p.66 Tejal Shah, Gary Gross; p.67 Chloe Paul, Laura Humphryis; p.68 Charanjeet Wadhwa, Thuy Vuy; p.70 Joshua Poole; p.72 Gary Gross, Samantha Souter; p.73 Thuy Vuy; p.74 Samantha Souter; p.76 Dianna Snape; p.77 Kathryn Marshall, Kristy Kozlowski; p.80 Dianna Snape; p.81 Arthur Sikiotis; p.82 Janette Pitruzzello; p.84 Jens Waldenmaier; p.86 Sophie Takach, Viva Partos; p.89 Russell Shayer; p.90 Soek Jin Lee, Jana Liebenstein, Romello Fereira, Michael Davies; p.91 Kathryn Marshall; p.96 Samantha Souter; p.97 Samantha Souter; p.100 Tori Costello, Tetsuhara Kubota; p.101 Jana Liebenstein; p.102 Erik Soh; p.103 Charanjeet Wadhwa; p.104 Dianna Snape, Jana Liebenstein; p.106 Samantha Sagona, Kathryn Marshall; p.107 Viva Partos; p.109 Dianna Snape, Jana Liebenstein; p.111 Dianna Snape, Michael Davies, Jana Liebenstein; p.112 Antonius Ismael, Samantha Souter, Charanjeet Wadhwa; p.113 Michael Davies; p.114 Dianna Snape, Gary Gross; p.115 Dianna Snape; p.118 Dianna Snape; p.119 Jana Liebenstein; p.120 Dianna Snape; p.121 Dianna Snape, Jana Liebenstein; p.122 Dianna Snape, Jana Liebenstein; p.123 Mahesh Haris; p.124 Gary Gross; p.126 Dianna Snape, Erik Soh, Charanjeet Wadhwa; p.127 Mahesh Haris; p.129 Michael Wennrich; p.130 Arthur Sikiotis; p.131 Arthur Sikiotis; p.132 Arthur Sikiotis; p.133 Arthur Sikiotis; p.134 Hugh Peachey; p.135 Hugh Peachey; p.136 Tejal Shah; p.137 Tejal Shah; p.138 Marcus Ferraro; p.139 Marcus Ferraro; p.140 Tejal Shah; p.141 Tejal Shah; p.142 Samantha Souter; p.143 Samantha Souter; p.144 Sophie Takach; p.145 Sophie Takach; p.146 Charanjeet Wadhwa; p.147 Charanjeet Wadhwa; p.148 Naomi Yang, Tejal Shah, Charanjeet Wadhwa; p.149 Hugh Peachey; p.150 Samantha Souter, Joanne Gamvros; p.153 Arthur Sikiotis, Tejal Shah, Ann Ouchterlony, Hugh Peachey; p.154 Joanne Gamvros, Russell Shayer, Tejal Shah, Hugh Peachey; p.156 Gary Gross; p.158 Michael Wennrich; p.159 Michael Wennrich; p.160 Michael Wennrich; p.161 Michael Wennrich; p.162 Michael Wennrich; p.163 Michael Wennrich; p.164 Viva Partos; p.165 Dianna Snape, Gary Gross, Russell Shayer, Thuy Vuy; p.166 Janette Pitruzzello, Gary Gross, Viva Partos; illustrations by Mark Galer; all other photographs by the author or from the RMIT Alumni Collection.

Contents

Creative Controls ... 101

Using Light .. 113

Lighting Still Life 127

Assignments .. 149

Introduction

This book is for teachers and students of photography working with small (35mm), medium (6 x 6, 6 x 7, 6 x 4.5cm) and large (5 x 4") format cameras in an environment where the light source can be controlled and the image output is to colour reversal (transparency) film. The source of light predominantly used in examples and assignments is tungsten. This is readily available in various forms, relatively simple technology, and as cost is always a factor in education, far cheaper than flash equipment. The sections dealing with fashion and portraiture make use of flash and its associated equipment.

With a strong commercial orientation the emphasis will be on technique, communication and design within the genres of still life, advertising illustration, portraiture and fashion. No attempt is made to elaborate upon the theory of photography. Terminology will be kept as simple as possible using common usage and avoiding complicated reasons why certain effects using cameras, light and film take place.

This is a practical guide to teaching and learning how things happen when working in a studio situation, not an extended theory of why.

Thuy Vuy *Chloe Paul*

Overview

Studio photography covers a wide range of disciplines. In its simplest form it involves mug shots (driver's licence, ID, passport, etc.), at its most complex cinematography for movies. Within this broad spectrum falls wedding, portraiture, fashion, catalogue, product, advertising illustration, industrial, corporate and architectural.

Although not covered in this book, it may seem that wedding, industrial, corporate and architectural photography do not fit in to the genre of studio photography. In most cases however the subject is usually interior with inadequate or nonexistent illumination and must be supplemented or totally lighted by artificial light sources.

Definition

A photograph taken in an interior situation (studio) that is devoid of natural influences, where the illusion of light, shade and contrast has been created by artificial means.

Introduction to teachers

This book is intended as an introduction to studio photography for full-time students of photography. The emphasis has been placed upon a practical approach to the subject.

A structured learning approach

The photographic study guides contained in this book offer a structured learning approach that will give students a framework for working on photographic assignments and the essential skills for personal communication.

The study guides are intended as an independent learning source to help build design skills, including the ability to research, plan and execute work in a systematic manner. Students are encouraged to adopt a thematic approach, recording all research and activities in the form of a Visual Diary and Computation Book.

Flexibility and motivation

The study guide contains a degree of flexibility often giving students the choice of subject matter. This allows the student to pursue individual interests whilst still directing their work towards answering specific criteria. This approach gives the student maximum opportunity to develop self motivation. It is envisaged you will introduce each assignment and negotiate the suitability of subject matter with the students. Individual student progress should be monitored through group meetings and personal tutorials.

Implementation of the curriculum

For students studying photography full time the complete curriculum contained in this book would cover the first and second semesters of the first year. The first series of nine assignments should be attempted under supervision. The second series of a further nine assignments are very much self directed. If the curriculum contained in this book is combined with **"Location Photography"** (also available in this series) this would constitute the entire first-year curriculum.

Revision exercises

The revision exercises in the study guides should be completed by the student within a specified time determined by a member of staff. This process will enable the student to organise their own efforts and give them valuable feedback about their strengths and weaknesses. The revision exercises should be viewed as another activity which the student resources and completes independently whilst being monitored. Students should then be encouraged to demonstrate the skills and knowledge they have acquired in the process of working through the activities and revision exercises by completion of all the assignments in the study guides **"Lighting Still Life"** and **"Assignments"**.

Introduction to students

The study guides you will be given during this course are designed to help you learn both the technical and creative aspects of photography. You will be asked to complete various tasks including research activities and practical assignments. The information and experience you gain will provide you with a framework for all your future photographic work.

Activities and assignments

By completing all the activities and assignments in each of the study guides you will learn how other images were created and how to communicate visually. In the second series of assignments you will be given the freedom to interpret the written brief. The images you produce will be a means of expressing your ideas and recording your observations. Photography is a process that is best learnt in a series of steps. Once you apply these steps to new assignments you will learn how to be creative and produce effective images.

Using the study guides

The study guides have been designed to give you support during your photography work. On the first page of each study guide is a list of aims and objectives identifying the skills covered and how they can be achieved.

The activities are to be started only after you have first read and understood the supporting section on the preceding pages. If at any time you are unclear about what is being asked of you, **consult a lecturer.**

Equipment needed

The course you are following has been designed to teach you studio photography with the minimum amount of equipment. You will need a camera with manual controls or manual override (if automatic). You will also need access to tungsten lighting, tripod, hand held light meter and a darkened studio work area. Large amounts of expensive equipment will not make you a better photographer. Many of the best photographs have been taken with very simple equipment. Studio photography is more about understanding and observing light, and then recreating lighting situations to achieve form, perspective and contrast when working with a two dimensional medium.

Gallery

At the end of each study guide a collection of student work will appear. All this work was produced by students working almost exclusively with tungsten light sources and colour transparency film.

Research and resources

To get the best out of each assignment use the activities contained in the study guide as a starting point for your research. You will only realise your full creative potential by looking at a variety of images from different sources. Artists and designers find inspiration for their work in different ways, but most find they are influenced by other peoples work they have seen and admired.

Getting started

Start by collecting and photocopying images relevant to the activity you have been asked to complete. This collection of images will act as valuable resource for your future work. Do not limit your search to photographs. Explore all forms of the visual arts. By using elements of different images you are not copying but using the information as inspiration for your own creative output.

Talking through ideas with other students, friends, family, lecturers or anyone that will listen will help you clarify your thinking and develop your ideas.

Hugh Peachey *Imogen Barlow*

Choosing resources

When looking for images, be selective. Use only high quality sources. Not all photographs printed are well designed or appropriate. Good sources include high quality magazines and journals, photographic books and exhibitions. You may have to try various sources to find suitable material. Be aware of what exhibitions are coming to your local galleries.

Visual diary

A Visual Diary is a record of all visual and written stimulus that may have influenced or formed the basis of an idea for the photographic assignments that form the major practical work to be completed.

In its most basic form this could be a scrapbook full of tear sheets (examples) and personal scribbles. It would however be of far more value if your Visual Diary contained more detail relating to an increasing awareness of your visual development in discriminating between good and bad examples. This should include design, composition, form and light applicable to any visual art form.

Joanne Gamvros

The Visual Diary should contain:
 ~ A collection of work by photographers, artists, writers, filmmakers relevant to your photographic studies.
 ~ Sketches of ideas for photographs.
 ~ A collection of images illustrating specific lighting and camera techniques relevant to studio photography.
 ~ Brief written notes supporting each entry in the diary.

Computation book

The Computation Book forms the documented evidence of all the practical considerations and outcomes that are associated with the completion of each activity and assignment. It should contain comprehensive information that would enable another photographer, who was not present at the original shoot, to reproduce the photograph almost exactly.

Ball 26/03/98

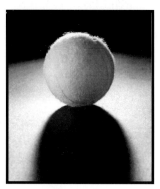

Film	Ektachrome 64T
Polaroid	Polapan Pro 100
Lighting ratio	Spotlight f64
	Floodlight f45
	Reflector f32
Meter Reading	Incident 2 seconds f45
Polaroid Exposure	3 seconds f45
Film Exposure	3 seconds f45
Process	Normal

Spotlight from back to create rim light. Floodlight from left, centre of light at point where front of ball falls into shadow. Creates gradual decrease in light across front. White reflector to right side of ball.

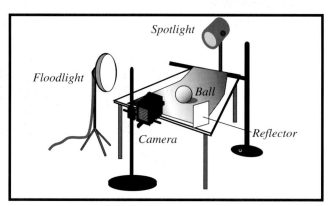

The Computation Book should contain:

~ An information sheet for each activity and assignment.
~ Technical requirements and equipment used.
~ Lighting diagram, camera to subject diagram, camera angle and height (measurements and specifications).
~ Meter readings of light ratios and exposure.
~ Film type, filtration, exposure, processing.
~ Props (use and source) and any other information relevant to each photograph.
~ All Polaroids.
~ Any processed film used to reach the final result should be kept.

Presentation

Research

In each assignment you are asked to provide evidence of how you have developed your ideas and perfected the techniques you have been using. This should be presented in an organised way so the assessor can easily see the creative and technical development of the finished piece of work.

Make brief comments about images that have influenced your work. Photocopy these and include them with your research.

Finished work

Presentation of work will influence your final mark. Design does not finish when the film is processed. If using 35mm film ensure transparencies are slide mounted. If working with a larger format, window mount transparencies in black card. Make sure the window you cut has square corners and is cut with a very sharp blade. Nothing looks worse than a well exposed transparency mounted in a window with ragged edges.

The Computation Book should be word processed and arranged so that is easily understood and submitted with your final folio. Write your name and project title on the back of your work so that it can be returned to you after assessment.

Viva Partos

Storage of work

Assignment work should be kept clean and dry. Use a folder slightly larger than the size of your mounted work. It is recommended that you standardise your final portfolio so that it has an overall 'look' and style. Negatives and transparencies should always be stored separately in appropriate sleeves or sheets, in a dust-free and moisture-free environment.

History

The camera in its most basic form, the camera obscura, has existed since the times of Aristotle. As photographic emulsions became available in the mid 19th century, photographers began to build or adapt artists studio to take photographic portraits. The camera and film took the place of the painter's canvas, brushes and paint. The primary source of light used by painters was, and in most cases still is, a large window or skylight built into the studio facing away from direct sunlight, and usually above and to one side of the subject. The use of this can been seen in paintings by Rembrandt, Michelangelo, etc.

Julia Margaret Cameron c1867

Liam Handasyde 1998

Early portrait and still life photographs show photographers took a similar approach to lighting their subject. By the 1840s commercial portraiture, advertised as 'sun-drawn miniatures', had practically eliminated hand painted miniature portraits, and the production of cartes-de-visite, or what we call today business cards, was thriving.

Photography's major disadvantage compared to a painting was that it was black and white. Attempts were made to hand colour these black and white images with limited success and early colour film and processes in the late 19th and early 20th century were impractical. It was not until the 1930s that colour photography became capable of producing colour at a consistent and reliable level.

Activity 1

Find and compile a selection of comparative examples of the use of similar light sources in paintings, early photographic portraits and contemporary photography. Compare and discuss your findings with other students.

Advancements in technology

Flash powder in its various forms was popular for a while, but as electricity became available more use was made of any new invention (vacuum tungsten lamp) that gave a more controllable, safer, continuous source of light. Coupled with advances in lens and emulsion technology shorter exposure times were achieved. The availability of this controlled continuous light source made the use of photography in portraiture common place. Photography in commercial advertising took longer. The first use of photography in appearing in newsprint was in the New York Daily Graphic in 1880. The first magazine entirely illustrated by photographs, the Illustrated American, was introduced in 1890. By 1915 most mainstream newspapers were using photography as the major source of illustration. There have also been major changes in camera and lens design, film format and the development of film emulsions with faster film speed (its ability to record an image with a very short exposure time).

1930 *Michael Wennrich 1997*

Light sensitive emulsion is no longer coated onto a glass plate just prior to exposure. Since the 1880s it could be purchased already coated onto a celluloid film. The ISO (film speed) has increased dramatically since the 1830s and colour film, although first used in the late 19th century has been commercially available since 1932.

Early cameras were large and cumbersome as the 'print' (called a contact due to the negative being placed in direct contact with the photographic paper and exposed to light) rarely exceeded the size of the 'negative'. From cameras having a film format as large as 36 x 44 " (the camera was mounted on wheels and drawn by a horse c.1860) we now record images of superior quality on a film format 24mm x 36mm (35mm) which in the case of motion picture are projected to the size of the cinema screen with out any apparent loss of definition. With digital imaging, where the image does not exist in any physical medium, enlargement is possible until pixel structure becomes evident.

Activity 2

By finding examples of the early use of photography in newspaper and magazines trace the development of the printing process's ability to reproduce black and white and colour photographs used in commercial and advertising illustration.

Current commercial practice

Although there has been a resurgence in the use of natural available light for portraiture in a studio situation, brought about by faster film with greater latitude (increase in susceptibility to light and contrast), the majority of studio photographs are lighted using artificial light sources.

These light sources fall into four main categories.

Type	Colour temperature	Output
Tungsten-Halogen	3200K	to 10kW
Photoflood	3400K	to 1kW
AC discharge	5600K	to 12kW
Flash	5800K	to 10,000joules

John Child

In common use at a commercial level (especially in the area of car photography) it is unlikely that AC discharge lights would be used in an educational situation.

Do not be confused by the colour temperature ratings shown above. It is enough to know that to get correct colour rendition you would use tungsten film with tungsten lights and daylight film with AC discharge and flash. Black and white film is relatively unaffected by the colour temperature of the light source. See study guide **"Light"**.

To best understand the output of these lights it should be taken into consideration that the average household light globe has an output of 100W. This means a 10kW (10,000W) tungsten lamp will have an output 100 times greater than the light in your bathroom.

This combination of faster film stock, efficient lenses and greater output of light sources has reduced studio exposures from hours to fractions of a second.

Methodology

The difference separating studio photography from all other forms is that the photographer has to create everything that will eventually appear in front of the camera. In most cases the photographer's starting point is an empty studio. With other forms of photography there is usually an environment, subject or distinct mood already in existence. Even if a subject does exist (person, product, etc.) what is the environment into which you are going to place that subject?

In some cases it could be a white background at other times something far more complex. Whatever the solution to the problem, the photographer has to create that environment using not only props but far more importantly light.

Thuy Vuy *Gary Gross*

Activity 3

Using the above examples as a guide to simple and complex backgrounds, find examples of where the subject matter is accentuated by the use of a plain background and where the subject is separated from a complicated background by the use of light and contrast.

Having established this difference, find examples where the image is confusing because of a lack of attention to this basic concept.

Gallery

Lachlan Bailey

Resources

A Concise History of Photography. Thames and Hudson. London. 1971.
An American Century of Photography. Hallmark. Missouri. 1995.
Encyclopedia of Photography. Crown Publishers. New York. 1984.
Photographing in the Studio - Gary Kolb. Brown & Benchmark. Wisconsin. 1993.
Photography - Barbara London and John Upton. Harper Collins. New York. 1994.
Photography Until Now. Museum of Modern Art. New York. 1989.
The History of Photography. Museum of Modern Art. New York. 1993.

Genres

Antonius Ismael

Aims

~ To develop knowledge and understanding of the history and development of the various genres of studio photography.
~ To develop an awareness of how photography changed our everyday life and how attitudes changed styles of photography.

Objectives

~ **Research** - Produce a Visual Diary containing the references and visual information that influenced the approach taken to each activity.
~ **Discussion** - Exchange ideas and opinions with other students and lecturers related to the activities you intend to research.
~ **Practical work** - Produce examples of research information relevant to the activities and the various genres of studio photography.

Introduction

The limitations of the photographic medium determined the first photographs were of still life subjects. Within a short period portraits of people capable of keeping still during the long exposures required were possible. As photographic technology advanced diversification took place. The physical and financial restrictions placed upon family portraiture diminished as film and lens speed increased. As printing and reproduction processes developed photography was used more and more as the primary source of visual reference. Today studio photography covers many genres. Within these fall advertising illustration, wedding, portraiture, fashion, food, catalogue and product photography. Advertising illustration surrounds us in an urban environment, but within advertising illustration there are many other genres. Fashion, portraiture, product (still life), car photography, etc. Each is a specialised area, but all have a common outcome. **Communication**. The style and power of visual communication has evolved in parallel to photography to the point where they are inseparable within the current concept of mass media. By definition commercial practice means that as a photographer you become part of the marketing mechanism by which manufacturers advertise their product. It becomes your responsibility to communicate its visual merits and advantages. The fashion photographer on the other hand is trying to create an overall effect that communicates 'life style' as a product merit. The catalogue photographer is more concerned with producing large volumes of work without sacrificing product detail. The main street portrait photographer is expected to make 'little johnny' look like 'little johnny' and the studio wedding and baby photographer is being paid to ensure a faithful record is kept of family members and sometimes to glamorise the ordinary.

Laura Humphryis

Activity 1

Using current magazines, newspapers and junk mail compile a collection of various types and uses of photography.

In your Visual Diary collate examples into their respective genres.

Compare with other students and discuss why one genre dominates compared to another. Collect similar examples from sources five to ten years old and determine whether the domination of one genre over another has changed. If so, why?

Advertising illustration

Advertising illustration covers many photographic genres. The most often seen being still life (product) and fashion. The greatest use of photography seen by the public is in the mass media. In newspapers and magazines the majority of images appearing are advertisements for one product or another. Photographic advertising illustration began when there was the capability to produce reproductions in large numbers. It has since become an effective tool of the advertising industry. The use of photography for advertising illustration started in the 1850s but was restricted to actual prints handed out to customers. Halftone printing processes saw the introduction of photographs for advertising during the 1880s. Black and white photographs were widely used by the 1920s and reliable colour reproduction became the dominant medium for advertising illustration from the 1950s.

1930s *Johanna McCubbin - 1990s*

During the 1970s and early 1980s advertising photography became synonymous with expensive high quality imagery and reproduction. This led to a move by photographers into the cinematography of TV commercials. Until that time the lighting in most TV commercials was turn on all the lights, flood the subject with sufficient light to create an image and keep contrast to a minimum. This approach was due to the inherited limitations of television technology. As technology improved the same skills photographers applied to their photographs were used in the production of TV commercials.

The purpose of a photograph is to communicate information and attract attention. In advertising this is achieved by the photograph either being used to support the headline and body copy or as the basis of the whole concept. See **"Art Direction"**.

Activity 2

Through the use of old magazines and newspapers trace the changes in styles of advertising over the last thirty years.

Photocopy your examples and file with publication dates and source in your Visual Diary.

Still life

The first photograph taken using light sensitive emulsion was a still life of the view from Niepce's workroom window (1826). This was more due to the length of the exposure (about eight hours in bright sunlight) than a creative decision to photograph something that didn't move. Early photography copied the approach of painters to their subject matter. This led to most examples of photographic images being centred on the stylised still life so popular with artists. The still life not only suited the long exposure times required by the film emulsions of the day but also provided a subject with which the photographer and the limited viewing public were familiar. Since then extensive use of still life has been used in advertising and commercial illustration. This can range from sophisticated photographs of perfume in expensive international magazines, visually and technically precise shots for the latest car brochure to product catalogues that turn up in your mail box.

In its current commercial form, still life photography can be broken down into two categories. Large and small. Small is called table top, but size is only limited by the size of the table. This could be anything from the inside of an expensive watch, a can of beans, a TV, to a sumptuous banquet. Large is everything else. Room sets, cars, trucks, right up to a Boeing 747.

RMIT

Activity 3

Find examples of still life photography. Your research should cover as a minimum national and international magazines, newspapers, car brochures and junk mail.

Compile your examples, in your Visual Diary, into a comprehensive presentation exploring the relationship between to the quality of photography and its purpose.

Portraiture

The first commercial use of photography was in the reproduction of portraits. Until photography became commercially viable painters had been the main source of portraiture. The process involved was long and painstaking for both the painter and the subject and the result was always only one picture. The photographic process was much shorter, almost immediate by the standards of the day. With the introduction of Calotypes in 1840 the production of a negative enabled the photographer to print as many copies as the customer required. In the 1850s small portraits called Ambrotypes were being produced with exposure times of between two and twenty seconds. These relatively short exposures made family portraits easier to co-ordinate and photograph. Photography became the primary visual history for families. Photographic portraiture remained however the privilege of the affluent.

In 1854 the French photographer Disderi made a major technical advancement. His process of exposing multiple images onto one negative (similar to multiple Polaroid passport cameras) substantially reduced the cost of portrait photography. He was one of the first photographers to promote photographs to the level of consumer desirables. He began the business of photographing celebrities, producing large numbers of prints and selling them to the public as a purely profit-making exercise. The celebrity pin-up, family portrait, wedding or new baby photographs were no longer the domain of the wealthy. This affordability was the beginning of the whole photographic industry as we know it today. By the 20th century photographic portraiture was available to everyone. The Kodak Camera released in 1888, followed by the Box Brownie in 1900 created a world-wide market for amateur photography. Although not photographed in a studio the average snapshot has as its dominant subject, people. Millions of photographic portraits are now taken every week.

Les Horvat *Imogen Barlow*

Activity 4

Through the use of family albums trace the development of film (from black and white to colour) camera technology and film processes. Photocopy your examples.

Date and place in chronological order in your Visual Diary. With other student examples trace as far back as you can.

Commercial portraiture

Portraiture began to appear regularly in magazines such as Vanity Fair and Vogue after WW1. The content of the portrait was usually a celebrity of the time and were the fore-runners of the pin-up and glamour magazines. The glamour portrait was to remain a benchmark until the 1960s when photographers such as Diane Arbus started to challenge the normal attitudes to portraiture with photographs of the less fortunate and society fringe dwellers. Between the wars with the availability of high quality small format cameras a genre that became known as 'environmental portraiture' became popular with photographers such as Arnold Newman being one of the main exponents. The major difference between the two genres, studio and environmental, is as the name implies the subject is photographed in their environment (home, work-place, etc.) and not in a formalised studio situation.

At a commercial level the local photographer, found in the main streets of most towns and cities around the world, has enough skill and technology available to him to produce a more than acceptable image. However the role of the commercial portrait photographer has been seriously challenged since the introduction of Polaroid, fully automatic cameras and various forms of rapid processing.

The great portrait photographers, amongst them Yousuf Karsh (b.1908) and Richard Avedon (b.1923), command large fees, and limited prints of their work are sold at a comparative level to works of art. They and others have made photographic portraiture equal in stature to the painted images photography had tried to replace. The whole process has gone full circle leaving a legacy of thousands of practising portrait photographers.

 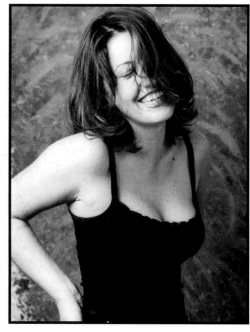

RMIT *Gary Gross*

Fashion

The first halftone reproductions direct from a photograph were appearing on a regular basis by the 1880s in magazines such as Les Modes and Vogue. Until that time a photograph was used as source material to create a woodcut or lithograph as part of the printing process. The images were still very much that of a rigid portrait. An inanimate person in a very structured environment. This was due not only to an inherited approach to the painted portrait but also to the limits placed upon the photographer and subject by long exposures. The requirement of the image was to show the design and quality of the garment as clearly as the processes of the time allowed. This was the start of what is now the most lucrative and sophisticated genre of photographic illustration.

From about 1911 onwards the use of soft focus and romanticism changed the look of fashion images appearing in Vanity Fair and Vogue. This was not a unique approach. The work of Julia Margaret Cameron had preceded this by over sixty years, but it was the first use at a commercial level in what we now call the mass media. It was not until the second decade of the 20th century that photographers such as Edward Steichen took fashion photography away from so called high fashion into the arena of 'style' with which it is associated today. As the attitude of women began to change in the 1920s so did the photographic approach to how they were shown. They were no longer shown as objects on which to hang clothes but as independent personalities who happened to be wearing the clothes.

The fashion photography of the war years of the 1930s and 1940s tended to reflect the feelings and limitations of the time. Fashion and design were determined by the materials available leading to an austere but natural approach to fashion imagery.

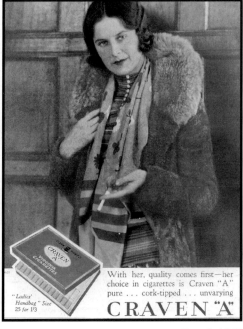

Punch 1930 *Karen Trist 1993*

Fashion since 1950

Gradual change took place in the post war 1950s. By the 1960s and 1970s gender equality and the use of colour began to dominate fashion images with its ability to create mood and excitement. Youth culture became fashion and fashion became youth culture.

A controversial change in content came in the late 1980s when a strong sense of independence, non gender specific sexuality, eroticism and voyeurism became a dominant theme in fashion magazines and magazines featuring fashion. A style developed with great success by Helmut Newton and Guy Bourdin. The antithesis to this was the dream-like work of Sarah Moon where the image took on a lyrical sense of imagination and unreal but desirable perfection. The garment was no longer the important object in the photograph. What wearing the garment could do for you was now the message.

During the development of fashion photography there was a distinction between advertising (design and quality) and editorial (lifestyle). Now the difference is hard to distinguish.

Fashion photography has now reached the stage where the lifestyle and image design is so important, and the design and quality of the clothes so obscure that in many cases there has to be a written explanation of what the model is wearing.

Tetsuhara Kubota *Terence Langendoen*

Activity 5

Using magazines and books as reference material compile a visual history of the changes in the style of fashion and fashion photography over the last twenty years.

Photocopy examples and compile a pictorial history in your Visual Diary.

Revision exercise

Q1. Name the main genres of studio photography?

Q2. The first photograph falls into which genre?

Q3. What invention enabled photographers to reproduce copies from an original photograph?

Q4. Which photographer is recognised as inventing the celebrity pin-up?

Q5. One product above all others has changed the public's approach to photography. What is it and when was it first put on the market?

Q6. What were the major social changes that shaped fashion photography since its inception?

Q7. Within the genre of fashion photography explain the differences between advertising and editorial photography?

Q8. Can these differences apply to other genres of studio photography?

Q9. Name three photographers who have influenced portrait photography?

Q10. Two magazines were instrumental in the reproduction of fashion photographs. Which two and when did they start?

Resources

A Concise History of Photography. Thames and Hudson. London. 1971.
An American Century of Photography. Hallmark. Missouri. 1995.
Encyclopedia of Photography. Crown Publishers. New York. 1984.
Photography - Barbara London and John Upton. Harper Collins. New York. 1994.
Photography Until Now. Museum of Modern Art. New York. 1989.
The Focal Encyclopedia of Photography. Focal Press. London. 1993.
The History of Photography. Museum of Modern Art. New York. 1993.

Gallery

Hugh Peachey *RMIT*

RMIT

Communication and Design

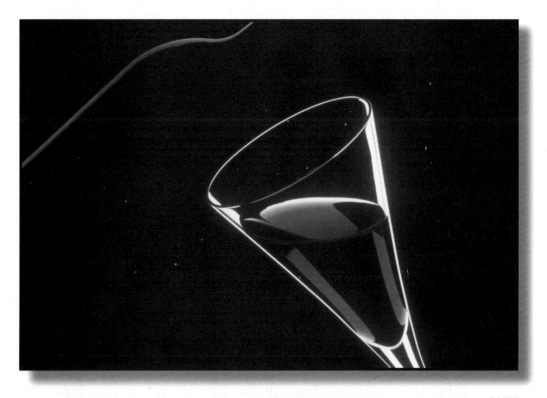

RMIT

Aims

~ To realise, and develop an understanding of how a photograph is a two-dimensional composition of lines, patterns and shapes.
~ To develop an understanding of how photographic techniques can influence the emphasis and meaning of the content of the image.

Objectives

~ **Research** - Produce research in your Visual Diary that shows an understanding of the role of composition and design in the creation of photographic images.
~ **Discussion** - Exchange ideas and opinions with other students and lecturers relevant to composition and design.
~ **Practical work** - Complete a series of activities that explore through research the importance of composition and design in photographic imagery.

Introduction

In the context of communication and design there is no right or wrong, only good and bad relative to the styles and tastes of the day. Unlike most other genres of photography the inspiration for a studio photograph has to be preconceived. Studio photographers cannot observe, compose and interpret by pointing the camera at the world around them. In a darkened studio there is no world around them. The studio photographer has to create or obtain everything that appears in front of the camera. Compared to other forms of photographic illustration this could be seen as a disadvantage. In actual fact it is a major advantage as the photographer has total control over all aspects of the photographic process. Studio photography is not a random process. It should be highly pre-produced and previsualised. Studio photographers, especially in the area of still life, do not capture images. They construct images. This enables the photographer to compose and design a photograph almost without restriction. The studio photographer can change perspective, contrast, point of view and lighting at will. When coupled with astute observation of the subject there are few limitations that can inhibit the design and composition of a photograph. Every element can be changed or moved to improve the image. It is the photographers skill that can turn a mundane subject into a remarkable image.

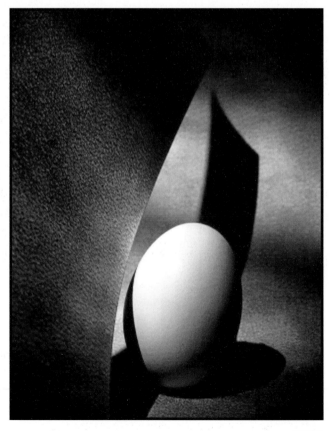

RMIT

Context

In reality the context of a studio photograph is the studio environment. The photographer can however create a different environment in which to place the subject. The context of the subject is therefore determined by the photographer and not by the subject. This enables a studio photographer to control, to varying degrees, the amount of information and thereby communication within each image. The image can be made obvious or ambiguous. Advertising illustration often excels at making the message obvious. Abstract images are by their very nature ambiguous. It is the viewer's interpretation of the photograph that the photographer is attempting to influence. A viewer can be guided towards an objective opinion by placing the subject on a plain background (e.g. an egg on a white background). The information is singular and indisputable. However, if the egg is placed in a box of straw and lighted and composed in such a way as to imply the egg is no longer in a studio, the viewer will be inclined to form a subjective opinion about the image. Imagination will create an environment that 'exists' outside the frame of the photograph.

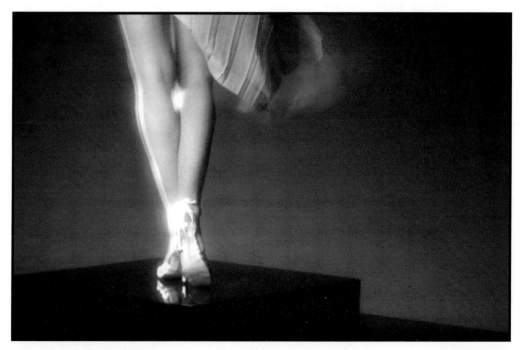

Ivan Shokal

Activity 1

Through research of contemporary sources find examples of photographs where you feel the photographer is guiding the viewer to make an objective opinion of the photograph. Do not limit the research to product and catalogue photography.

Discuss with other students and lecturers what could have been changed in the photograph to encourage the viewer make a subjective opinion.

Photocopy examples and compile in your Visual Diary.

Format

Format describes the size and proportions of an image. It applies to both **'image format'** and **'camera format'**. The difference need not be confusing as the outcome is the same.

Image format

A vertical image is described as **'portrait format'** even though the dominant composition may be horizontal. A horizontal image is described as **'landscape format'** even though the dominant composition may be vertical. The terminology dates back to when artists first started to turn a rectangular canvas one way or the other to suit their subject matter. When working with an Art Director or Designer the image format will be determined by the layout and final medium. In editorial work photographers must often ensure images are composed using both formats. This enables greater flexibility with page design.

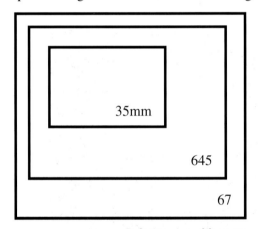

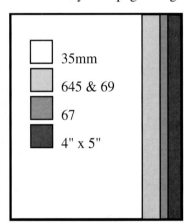

Relative size of formats *Relative shape of formats*

Camera format

Format also describes the size of camera being used (small, medium and large). Each of these cameras uses different size film. The decision to use a particular format may lie with the client's requirements for reproduction (image quality) or the practicalities of one camera over another.

Small format cameras frame images are narrower than the proportions of a single page. The 6 x 4.5 and 6 x 9cm medium format cameras frame images in proportion to the size of this page. That is to say, if the size of the image was increased to the size of this page the image would fit exactly. The medium format 6 x 6, 6 x 7, 6 x 8cm and large format (5 x 4") cameras frame images shorter than the proportions of a single page. In these cases some of the visible image in the viewfinder will be lost when reproducing a full page image. This should be taken into account when composing an image required to fit a specific layout format. This problem can be overcome by masking off the view finder to the proportions determined by the client's layout. See **"Art Direction"**.

Content

Viewing the subject in relation to its background is essential to forming an understanding of compositional framing. By definition a background is something secondary to the main subject matter. It should be at the back of the image and of relatively less or little importance. This does not mean it should be ignored, but should be controlled. It is a common fault of most photographic students to position the camera too far away from the subject. This is compounded by the problem of filling in the empty space (background) created by this point of view with too many props. Too much information can lead to confusing photographs. Keep it simple is often the best rule. Move closer, reduce the background to a minimum. Move even closer until the subject fills the whole frame and becomes the dominant part of the composition. A truck full of props is no substitute for a strong visual awareness of the virtues and merits of your subject, a preconceived idea of its context and the purpose of the communication.

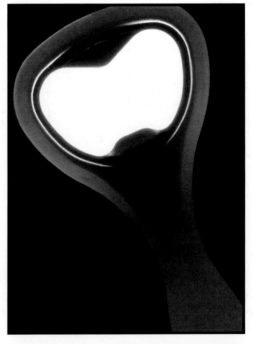

Michael Davies

Activity 2

Through research of contemporary sources find examples of photographs where the photographer has used a simple background to enhance composition and to focus attention on the subject matter. Do not research product and catalogue photography.

Discuss with other students and lecturers whether the same subject matter could be made to work on a more complex background.

Photocopy examples and compile in your Visual Diary.

Balance

In nature there is a natural balance or harmony of texture, shape, form and colour. Many objects upset this balance and impair the visual relationship between one object and another. It is this control of balance by the photographer, whether to achieve harmony or discord, that determines the level of acceptance of an image by the viewer. As humans we naturally gravitate towards a balanced image (symmetrical). When there is a symmetry between the elements within the frame the image is said to have a sense of balance. A balanced image although pleasing to the eye can sometimes appear bland and conservative. Knowing this a photographer can change the balance of an image to achieve a different result. A dominant element of balance is visual weight created by the distribution of light and dark tones within the frame. To frame a large dark tone on one side of the image and place tones of equal visual weight on the other side will create an imbalance. An unbalanced image (asymmetrical) will often create visual tension, interest and a sense of things not being as they should be. The communication of harmony or tension is the deciding factor when composing an image intended to convey a specific message.

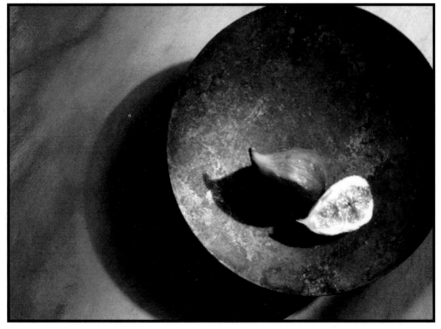

RMIT

Activity 3

Find examples where the photographer has used a sense of imbalance to create tension within the image.
Find examples where the photographer has used visual balance to create visual harmony.
Photocopy examples, discuss with other students and compile in your Visual Diary.

Composition

Composition is not a question of getting all the relevant information in the frame. Although information is necessary it is more important to attract and keep the viewer's attention. This calls for composition where the subject matter receives prominence without distraction from other elements within the frame. In this way composition compliments communication. The image should encourage the viewer to explore the image without complicating the communication and decreasing the importance of the subject matter. The subject should be viewed as a two-dimensional object. This will help the photographer become aware of distractions to the composition that could confuse the communication. Avoid placing the main subject matter in the centre of the image. Use the whole frame in which to compose your image. You are paying for every part of the film, so use it.

Rule of thirds

Rules of composition have been formulated over the centuries to help artists create harmonious images. The most common of these rules are the 'Golden Section' and the 'Rule of Thirds'. The Golden Section, dating back to the time of Ancient Greece, is the name given to the traditional system of dividing the frame into unequal parts.

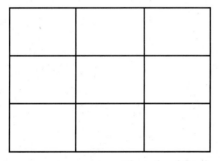

The rule of thirds is the simplified modern equivalent. Visualise the viewfinder as having a grid which divides the frame into three equal segments, both vertically and horizontally. Use these lines and their intersecting points as key positions to place significant elements within the image.

The rule of thirds

Activity 4

Through research of contemporary sources find examples of photographs that follow the rule of thirds and examples that do not.
Discuss with other students and lecturers whether the same subject matter could be made to work with a different approach to composition and design.
Could breaking the rules improve the communication?
Photocopy examples and compile in your Visual Diary.

Point of view

Working in the studio a photographer has ample time in which to explore the subject in great detail. With the exception of fashion and portraiture the studio photographer is not limited to capturing that precise moment in history that will never occur again. This gives the photographer the opportunity to view the subject from all possible angles without the risk of 'losing the shot'. Start with, but immediately discard, the 'normal' viewpoint. Look for something different and unusual but still capable of communicating with the viewer. Try different focal length lenses. Try climbing a ladder or lying on the floor. Forget how you would see the subject from a normal vertical position and try to visualise how the camera, which is not subject to any normal viewpoint, might be used to interpret the subject.

David Peakal

Line

Western visual culture has determined the way we look at images. From the moment of our first visual encounter with images and the written word our eye has been conditioned to viewing what is in front of us following certain patterns of perception. We instinctively scan images from top left to bottom right. The same way we read. This element of design is a major factor in the success of the communication. Lines, whether horizontal, vertical or diagonal lead the viewer around an image. If the flow of the image is easy to follow, and therefore unnoticeable, the intended communication is more likely to succeed. If the flow is interrupted by poor use of line the viewer will lack visual guidance, not understand the communication and possibly disregard the image.

Horizontal lines

The horizontal line is often the dominant line in a image. Everyone is aware the horizon is level to their normal viewpoint. Horizontal lines within the image will therefore give the viewer a sense of stability and balance when correctly aligned with the edge of the frame. Incorrect alignment may upset this static perception and the image could appear unbalanced.

Vertical lines

Our perception of the vertical line is as strong as that of the horizontal. Its use in composition and design is similar. The horizontal line divides an image from top to bottom, vertical lines divide an image left to right. The horizontal line guides the viewer left to right, the vertical line guides the viewer top to bottom. When correctly aligned to the edge of the frame vertical lines will give a static composition with a sense of strength, power and dominance. When vertical lines are tilted within the frame this perception is reduced and replaced with a sense of imbalance. However converging vertical lines create perspective and can lead the viewer to an implied horizon and visual stability.

Diagonal lines

Horizontal and vertical lines when correctly aligned to the frame create a sense of stability relative to a normal viewpoint. Diagonal lines are not relative to the normal perception of stability and are therefore viewed as unstable and precarious. Whether actual or perceived the visual tension created by the use of diagonal line can lead to dynamic composition and a sense of movement within the image.

Curves

Images are viewed from top left to bottom right. A curved line achieves this progression in an unobtrusive and orderly way. Curved lines are soothing to the eye and depending on their degree of curvature unlikely to create visual tension and discord. When placed close to the edge of frame the effect of the curve is greatly enhanced.

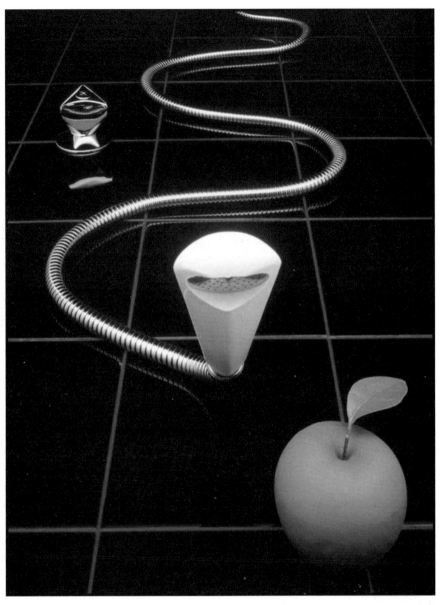

RMIT

Activity 5

In the example above discuss with other students and lecturer which elements of design
have been used to the best effect. Is one design element stronger than another?
Also find examples where the photographer has used horizontal line to create stability and
examples where the photographer has used vertical line to create visual dominance.
Photocopy examples, discuss with other students and compile in your Visual Diary.

Depth

A photograph is usually a two-dimensional representation of a three-dimensional subject. To imply a sense of depth within an image a studio photographer can artificially create dimension by placing objects in front of (foreground) and behind (background) the main subject matter. The foreground objects will appear larger than the subject and the background objects will appear smaller. This illusion of depth can be increased by careful use of line, tonality, contrast, colour, depth of field and framing. When these elements work successfully the viewer will create the third dimension in their mind.

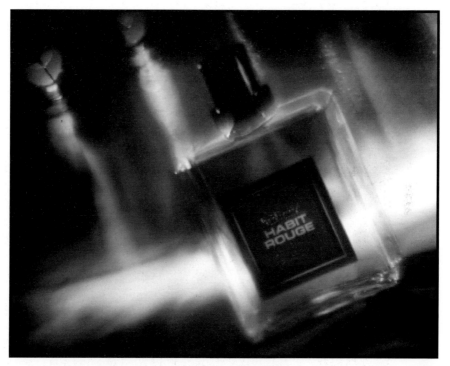

RMIT

Activity 6

Through research of contemporary sources find examples of photographs where the photographer has used the concept of depth to create a two-dimensional image of a three-dimensional subject.

Comment and discuss with other students and lecturers why you think the composition and communication works.

Discuss with other students and lecturers whether the same subject matter could be made to work with a different approach to composition and design.

Photocopy examples and compile in your Visual Diary.

Perspective

Visual perspective is achieved by the creation of depth and distance within a two dimensional medium. Our perception is that parallel lines converge as they recede towards the horizon and objects diminish in size as the distance between them and the viewer increases. Because the human eye has a fixed focal length this perspective cannot change. Most cameras however can be used with lenses of differing focal lengths. This means the photographer can alter perspective by changing the focal length of the lens. A normal lens has a perspective similar to the human eye. A long lens will compress perspective and create the illusion that elements within the frame are close together. A wide angle lens will exaggerate perspective, distort the perception of distance and scale and create the illusion that elements within the frame are further apart. See **"STUDIO"**.

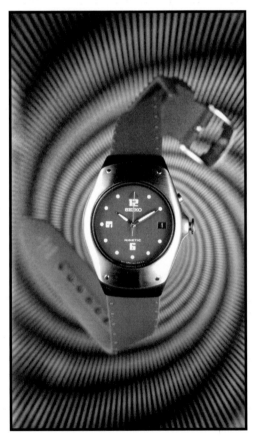

Joshua Poole

Activity 7

Find examples where the photographer has created perspective within the image. Photocopy examples, discuss with other students and compile in your Visual Diary.

Revision exercise

Q1. A viewer can be encouraged to make an objective opinion of an image by having simple or complex content?

Q2. We instinctively follow a pattern of visual perception when looking at an image. What is that pattern?

Q3. Where can a curved line be placed within a composition to greatly increase its effect?

Q4. What is the most obvious way to create depth within an image?

Q5. A horizontal image would best be suited to which image format?

Q6. Which camera format would best be suited to an A4 layout?

Q7. A photograph can be described as having a visual imbalance. What does this mean?

Q8. When composing an image where should the photographer avoid placing the main subject matter?

Q9. Horizontal lines create a sense of stability. What type of line creates tension?

Q10. Name three ways in which the communication of an image can be increased?

Resources

Basic Photography - Michael Langford. Focal Press. London. 1997.
Encyclopedia of Photography. Crown Publishers. New York. 1984.
Photography - Barbara London and John Upton. Harper Collins. New York. 1994.
The Focal Encyclopedia of Photography. Focal Press. London. 1993.
The Image - Michael Freeman. Collins Photography Workshop. London. 1990.

Gallery

Charanjeet Wadhwa *RMIT*

Soek Jin Lee

Art Direction

John Child

Aims

~ To develop knowledge and understanding of the process of working with an art director, art direction terminology and outcomes.
~ To develop an awareness of how photography is influenced by the demands of a layout and the requirements of a client.

Objectives

~ **Research** - Produce a Visual Diary that contains the references and visual information that influenced the approach taken to each activity.
~ **Discussion** - Exchange ideas and opinions with other students and lecturers related to the activities you are asked to research.
~ **Practical work** - Produce examples of research information relevant to the activities, process, terminology and outcomes of photographic illustration and art direction.

Introduction

Unless working exclusively as a portrait photographer, most commercial photographic projects, whether editorial or advertising, still life or fashion, will involve working under art direction. This involves working to a specific set of guidelines set by the art director or designer and for most of the time having that person 'looking over your shoulder'. The art director is responsible for more than just ensuring you take a good photograph.

Working with art direction

Most commercial assignments are at the request of someone else – the client. It is this commissioning process that makes it the photographer's role to supply the client with the photograph they are prepared to pay for. Because they are paying they have a say in how you photograph the subject, whether it be a car, themselves or someone's dog. It is important to take note of their requests and supply a photograph that complies with their requirements. The process should be a combination of the skills of all the parties involved. Editorial assignments have less contrived and predetermined guidelines within which a photographer has to compose and produce a photograph. The brief is usually governed by the number of photographs per page and an outline of the general content of the subject matter in relation to the text.

With an advertising agency or designer, where the role of the art director is very much an integral part of the production of the final photograph, the requirements are far more precise and demanding.

Art Directors and designers

Before a photographer is commissioned to photographically illustrate an advertisement, the art director/designer would have submitted countless ideas at numerous creative meetings. These meetings involve the creative team (art director and copy writer) the creative director (leader of all creative teams within an advertising agency) and in the initial and final stages the client. This process can be long and arduous. Many ideas will be submitted but only one will be accepted by all parties. By the time the surviving idea reaches the photographer the idea and layout have become very refined and precise. It is imperative therefore the photographer produces exactly what is wanted. In these circumstances photographer and art director/designer work as a team so a result acceptable to a third party (the agency's client) is achieved. Working to an agreed plan, known as a layout, is the blueprint all concerned follow in order to produce an end result acceptable to all.

Activity 1

Using magazines, newspapers and direct mail advertising collect a series of advertisements that have varying amounts of art direction and copy writing. A direct mail catalogue will have less art direction per image than an advertisement for an international perfume. Compile in your Visual Diary advertisements you consider more effective than others. Discuss with other students and lecturers the visual merits and failures of each.

Layouts

A layout is the format decided by an art director/designer into which the photograph, headline and body copy (text) have to combine to form an integrated whole. It is a guide to ensure all the elements visually fit together and become a piece of art work that serves, in the case of advertising, the purpose of attracting attention to the product. Rarely does the photographer have the opportunity to take photographs and have the art director incorporate headline and body copy later. It is nearly always the other way around.

The graphic designer and art director's role is to take all the components, (photograph, headline, body copy, client logo) and assemble them in a cohesive form. The finished piece of art work must be acceptable to the client and capable of being produced and printed to budget.

After the initial briefing at which the photographer is informed of all the requirements of the photograph, most clients will request a written estimate of costs to produce the photograph. Upon acceptance of this estimate a period of time (pre-production) is allowed in which to prepare for the shoot. This involves the complete organisation of all the elements required to be in the final photograph. It is at this stage the photographer should offer information and advice regarding the practicalities of the layout. If it is obvious to the photographer elements of the layout are not achievable at a practical or financial level it should be mentioned at the briefing or during the pre-production period. **Do not leave it until the day of the shoot.** Throughout this process it is important to constantly relate back to the layout and the brief. It is better to oversupply equipment and props than to be short on the day when your reputation as a photographer and organiser is on display. Leave nothing to chance. Organise.

Organisation

Do not assume all the equipment will work. Check everything first. Do not limit your choice of lenses and associated equipment. Assume the art director may change his mind or request an adaptation to his original idea as he sees the photograph take shape. If you suggest changes ensure you can fulfil your idea. If the brief asks for a plate and a water melon make sure there are at least six different plates and a selection of water melons available to choose from. If the brief asks for black and white ensure plenty of black and white and colour is available. Over supply and over compensate. See **"The Studio"**.

Activity 2

Using current magazines, newspapers and direct mail advertising collect a series of advertisements. Photocopy each one four times. Cut out each element, headline, body copy, logo and photograph and collate separately in your Visual Diary.

With other students mix and match elements from various advertisements.

Discuss with lecturer and other students whether there is a general pattern to photographic illustration when used for advertising?

Does the product sometimes determine the aesthetic photographic approach?

Framing the image

Photographs used in completed pieces of art work are rarely random images. They are images that relate to the message the art director is attempting to get across to the public. It is essential to fully understand what the art director is trying to say with this combination of words and pictures. Suggestions by the photographer are usually welcome if there is a genuine attempt to improve on the outcome. To suggest radical changes will meet with resistance. This may not necessarily be because the art director disagrees with you but because any major change would require a re-submission to the agency of any new idea that differs from what the client has agreed to pay for.

This is valid in any form of commissioned photography. If someone is paying you to photograph their dog in his favourite kennel suggest variations upon this theme but do not be surprised if you meet resistance when you suggest the idea of maybe photographing the dog in a bath full of bubbles. It may seem like a great idea to you but the client may hate how the dog looks when it is wet. Do not feel obliged to make any suggestions if it is obvious that the client has a firm opinion of what they expect from you. Judge each job on its merits.

Format

As well as creative constraints there are physical restrictions placed upon the photographer when it comes to composition. If the layout is a single full page advertisement the camera should be orientated to a portrait format (vertical). A double page spread would see the camera set to landscape (horizontal) and allowance made for the inclusion of a gutter (where the staples go) when composing the photograph. A double page spread should look as if it is one photograph although made up of two separate but connected images. A billboard would be horizontal format, an in store poster could be either. This is a guide where the rules can change. Once the orientation and format has been decided allowance for areas within the composition must be left for the headline, body copy and the printing process.

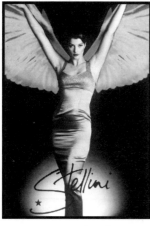

Single page -
Johanna McCubbin

Double page spread - Samantha Souter

Text and bleed

In a single full page advertisement where the photograph is printed to the edge of the page the text (words) will be printed over the image. The choice of typeface used to print this text is chosen by the art director. The positioning of these various pieces of text (headline, body copy) is known as typography. In a single page advertisement where the photograph is contained within the page the typography will appear on the page and not over the image. These rules also apply to double page spreads, twenty four sheet posters (billboard), point of sale (seen at the end of supermarket aisles), in store posters, catalogues and any form of finished art where there is a combination of photography and words.

Bleed is the term that refers to the amount of excess image area allowed around the edges of a photograph that will disappear in the printing process. This is done to eliminate the possibility of white edges appearing when the finished piece of art work is scanned and printed. If the art work is slightly greater in size than the paper it is being printed on any chance of the edges of the paper not being printed has been reduced. This is especially important with very large print runs.

Single page - Sabina Bukowski

Single full page - Adam Howden

Activity 3

Find examples of the various photographic formats used in magazine and newspaper advertising.

Find examples where different formats have been used for the same advertisement (e.g. single page and billboard).

Discuss and compare with other students and compile in your Visual Diary for reference.

Revision exercise

Q1. When referring to typography an art director is talking about which element of a piece of art work?

Q2. What is the name given to the guideline to which the photographer has to work?

Q3. In a double page spread allowance should be made for what part of the printing process?

Q4. The camera should be orientated to which format when taking a photograph for a single full page advertisement?

Q5. Is there greater flexibility when working to an advertising layout or to an editorial brief?

Q6. What would be the most likely result if an art director made no allowance for bleed when sending the final piece of art work to the printers?

Q7. What process has the layout been through before it reaches the photographer?

Q8. What is the key word for the successful completion of a photographic commission?

Q9. The art director is responsible for the overall look of the advertisement. Who writes the copy (text)?

Q10. As a photographer commissioned to take a photograph your responsibility is to whom?

Resources

A Concise History of Photography. Thames and Hudson. London. 1971.
An American Century of Photography. Hallmark. Missouri. 1995.
Basic Design & Layout - Alan Swann. Phaidon Press. London. 1993.
Encyclopedia of Photography. Crown Publishers. New York. 1984.
Photography - Barbara London and John Upton. Harper Collins. New York. 1994.
Photography - Selected from the Graphis Annuals. Page One Publishing. Singapore. 1993.
Photography Until Now. Museum of Modern Art. New York. 1989.
The Focal Encyclopedia of Photography. Focal Press. London. 1993.
The History of Photography. Museum of Modern Art. New York. 1993.
The Image - Michael Freeman. Collins Photography Workshop. London. 1990.

Gallery

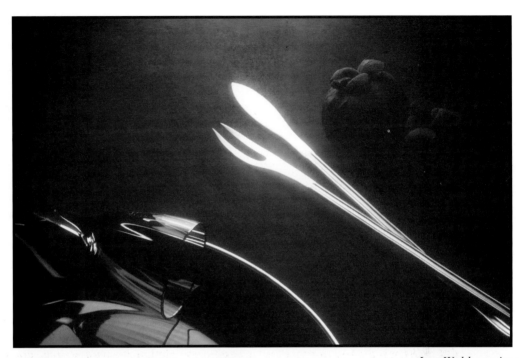

Jens Waldenmaier

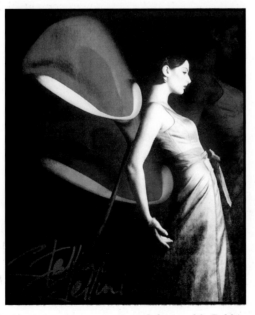

Johanna McCubbin *Erik Soh*

Gallery

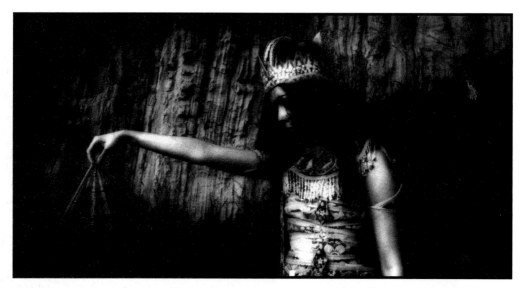

Antonius Ismael

Saville Coble

The Studio

John Child

Aims

~ To develop knowledge and understanding of the use of artificial light sources, camera and associated equipment in a studio environment.
~ To develop an awareness of the equipment and organisation required for the photographic control of lighting ratios, contrast and exposure.

Objectives

~ **Research** - Produce a Visual Diary that contains all the reference gathered in completing the activities, and all visual information that influenced the approach taken when producing the photographs for each activity.
~ **Discussion** - Exchange ideas and opinions with other students and lecturers related to the photographs you intend to research and produce.
~ **Practical work** - Produce photographic colour transparencies and Computation Book information relevant to the technique and production of each photograph.

Introduction

Studios range in size from small areas surrounded with black curtains to large film stages in Hollywood. The instant photographic booths found in many public areas are miniature studios. They are an area devoid of external light in which there is a controlled light source. This is the basis of any photographic studio. Size is not as important as efficiency. To set up a studio that will function within the requirements of this book need not be a complex or unachievable task.

Size

A floor area for each photographer working with camera, lights and table top set up should be approximately 6m x 6m, with a working height of 4 metres. This is an ideal minimum. The reality is sometimes different. Whatever size can be achieved it is important to ensure that the area is uncluttered and free of any thing that could cause injury. Bear in mind that other than the lighted subject the studio area will be in almost total darkness.

Power

After determining size the most important criteria is the supply of power. Ensure it is safe. Have a qualified electrician install sufficient power (amount of current-amps, and number of outlets) for the equipment that will be used. An imperative safety factor is the installation of circuit breakers (breaks power circuit at the instant of any electrical fault). Distribution boards (the supply is divided into multiple outlets) with overload switching facilities (breaks delivery of current to the equipment being used) is also recommended as an extra precaution. Also make sure the normal lights within the studio can only be turned on or off from within the studio and there is adequate ventilation.

Darkness

The only light that should exist in a studio is that created by the photographer. To achieve this blacken out the entire work area. This can be done with dark heavy curtains over windows and painting the walls and ceiling a dark matte grey. Where possible the floor colour should also be dark. The result should be an area that has no external light entering and surfaces of minimum reflectance. If money allows each work area within a large studio should be separated from each other by heavy non reflective curtains so that more than one photographer can be working at one time. If large format cameras are used a light proof area will be required to load film into double dark slides.

Activity 1

Within your designated area design (complete with measurements and dimensions) a practical workspace that can be used as a photographic studio. Research the current safe working practices for the supply of power and working with electricity.

Health and safety

Power supply

It cannot be stressed strongly enough that the lighting equipment and studio power supply be either installed, or checked in the case of existing supply, by a qualified and licensed electrician. **Without question working with powered light sources is the most dangerous part of a photographer's job.** As a photographer it is inevitable light sources are taken for granted and unfortunately familiarity leads to complacency and poor safety practices.

- Electricity is dangerous. It can kill you.
- Never attempt to repair lights or wiring unless you are absolutely confident that you know what you are doing.
- Always turn off the power and disconnect the cable before changing a globe.
- Never touch any part of a light or cable with wet hands.
- Exercise extreme care when photographing liquids.
- Always turn off the power to the flash pack when changing flash head outlets.
- Always be cautious when moving or connecting lights.
- Never use liquids near electricity.
- Use heat resistant gloves when handling tungsten lights.
- Wear shoes with rubber soles.
- Ensure all students know **where and how** to use the First Aid Kit.
- Ensure all students know **where and how** to use the Fire Extinguisher.
- Ensure all students are aware of emergency procedures related to work area.
- Ensure adequate ventilation of the studio area.

Tori Costello *Marcus Ferraro*

Equipment

Essentials

- An area devoid of external light sources, preferably a room with no windows or one capable of being darkened by the use of heavy curtains or blinds.
- An AC power supply with circuit breakers, distribution boards and extension cables.
- Camera, lenses, accessories.
- Two 500W flood lights, two 650W Fresnel spotlights and associated stands.
- Heavy duty tripod, preferably with rising central column or arm.
- Hand held light meter capable of measuring flash and ambient light.
- Film and Polaroid.
- Polaroid back to suit camera.
- 18% grey card
- **First Aid Kit**.
- Appropriate **Fire Extinguisher**.
- A system of stands and poles from which to hang background material.
- Stands (**'C-stands'**) to support reflectors, diffusion material, colour filtration.
- Table top.
- Preparation or work bench.
- Gaffer tape, heat resistant tracing paper, reflectors, Stanley knife, heat resistant gloves.

Other essentials

This is equipment you accumulate as you start to take photographs.

- Colour correction filters. See **"Light"**.
- Light box.
- Viewing loupe.
- Large roll of seamless paper.
- Clamps (various sizes).
- Sand or shot bags.
- Make-up mirror with lights.
- Refrigerator (to store unexposed film at constant temperature).

Darkroom

Although a light proof area is needed for the loading of large format film into double dark slides a requirement for darkroom facilities in commercial practice is not necessarily required as processing and printing can be done ex-studio. As digital replaces analogue darkroom and processing facilities will be completely removed.

Camera

With the occasional use of small format for fashion most studio photography is undertaken using medium or large format cameras. Apart from the difference in film size, small and medium format cameras differ little in their use and capabilities, although Polaroid availability for small format is limited.

Most small and medium format cameras have through the lens (TTL) metering with manual over-ride, a preview system for viewing the subject at the aperture chosen for exposure and a film advance mechanism to move a roll of film, frame by frame, past the film plane after exposure.

The main difference between the two formats is the shutter mechanism. In most small format cameras the focal plane shutter is parallel to and almost touching the film. Two blinds follow each other across the film plane (24mm x 36mm) in a horizontal or vertical movement in order to expose the film to light. This is the reason for the relatively slow shutter speeds that are used for flash exposures.

In most medium format and all large format cameras the shutter is between the lens elements that make up the camera lens. This means as the size of the aperture is all that has to be opened and closed (at f64 this could be the size of a pin head), light and synchronised flash light can be instantly transmitted onto the film plane at any shutter speed.

Large format - tungsten light source
Michael Wennrich

Small format - flash light source
RMIT

Large format cameras although old in design and technology (except for lens design they have changed little since first used in the 19th century) have many distinct advantages. Their main difference is the lens (front) and film plane (back) can be moved independently of each other. In its simplest form this means any magnification of subject size can be obtained, using any lens, by moving the front and back panels further away from each other.

By changing the front and back of the camera from parallel to non-parallel and at varying angles to each other, distortion can be corrected or created at any subject to camera angle. Maximum depth of field (nearest and furthest points in focus) is obtainable at maximum aperture (lens wide open), and creative use of selective focus can be achieved.

Lenses

Modern cameras have detachable compound lenses that enable photographers to use one camera body with a wide range of lenses. A compound lens is made up of many lens elements which in combination determine its focal length and maximum aperture. The minimum requirement for a student of photography would be a normal, wide, and long lens.

Format	Normal	Wide	Long
Small	50mm	24mm	100mm
Medium	90mm	50mm	180mm
Large	180mm	90mm	360mm

A normal lens is the term applied to a lens with a focal length equal to the measurement of the diagonal of the film format with which it is being used. This is approximately equivalent to the normal perspective of the human eye. A wide angle lens will give a field of view wider than normal and a long lens will give a field of view narrower than normal. A wide angle lens will apparently increase and distort perspective, a long lens will apparently compress perspective due to closer and further viewpoints respectively.

Normal *Wide* *Long*
Jana Liebenstein

Activity 2

Load a camera with tungsten reversal film.
Light a subject on a neutral background with a diffuse light source (flood light).
Photograph the subject with a normal lens.
Without moving the subject or camera position repeat the process with as many lenses as are available (minimum of wide and long).
Keep a record of exposure and the focal length of each lens for each frame exposed.
Process the film and correlate the transparencies with the written record.

Focus

With through the lens viewing an understanding of focus is best explained at a practical level. The closer the lens to the subject the greater the distance from the lens to the film plane. The further the lens from the subject the shorter the distance from the lens to the film plane. This means that as the size of the image increases in the viewfinder the distance from the lens to the film plane increases.

Aperture

Within the lens is an adjustable diaphragm used to control the intensity of light entering the camera. This is known as aperture. The numerical measurement of aperture is known as f-stop. F-stops can range from f1.2 to f90 and beyond. When moving from one f-stop to another a series of clicks can be felt. Each stop and half stop has a click. Each full f-stop will halve the amount of light entering the camera when changing from a lower to a higher number. Each full f-stop will double the amount of light entering the camera when changing from a higher to a lower number. See **"Exposure"**.

Time

On most medium and all large format cameras exposure time is controlled by a shutter mechanism fitted between the elements that make up a compound lens. These shutter speeds vary from fractions of a second to any length of time the photographer determines. These periods of exposure time are equally applicable to small format cameras, but the shutter mechanism (focal plane shutter) is at the film plane and not inside the lens. See **"Exposure"**.

Accessories

It is important to have at least a standard lens hood, cable release and with large format cameras a dark-cloth and double dark slide. The lens hood will reduce lens flare (direct light from the source entering the lens) and the cable release will eliminate camera vibration during exposure. This is essential when using long exposures. A dark-cloth is required to view the image on the ground glass plate at the back of a large format camera and a double dark slide (cut film holder) is used to place film at the film plane.

Activity 3

Load a camera with colour transparency film.
Point the camera, mounted on a tripod, at a tungsten light source. Turn on the light.
Without looking through the camera make an exposure each time you gradually move the camera away from the light source until it is at 90 degrees to the light.
Repeat the procedure using a lens hood on the camera.
Process the film and record the difference between the angle of the camera to the light when using and not using a lens hood (when flare disappears).

Light sources

Tungsten

There are many variations upon the two basic tungsten light sources. They all fall in to the two major categories, floodlight and spotlight. The majority have a colour temperature of 3200K and are compatible with tungsten colour film and any black and white film. The minimum requirement to teach and learn the use of tungsten light would be a single floodlight and a single spotlight. A simple flood light would have an output of 500 watts and a spotlight suitable for the purposes of this study guide around 650 watts.

When setting up a studio buy the most robust lights and stands you can afford within the output range mentioned above. Keep a stock of spare globes and exercise caution when handling the lights and the power supply. If possible all light stands should have wheels to ensure ease of movement and to reduce vibration when moving a light. Professional spotlights come with barn doors and nets. Barn doors are metal flaps that are used to control the shape and amount of light falling on the subject. Nets are pieces of wire gauze of varying densities that reduce the output of the light by diffusing the light at its source without greatly affecting the shadows.

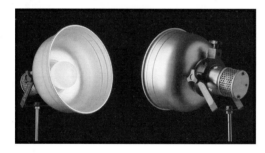

Floodlight

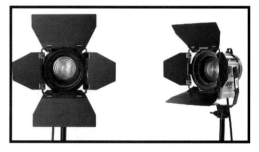

Spotlight

Flash

As with tungsten lighting there are numerous flash equivalents of the two standard light sources, flood and spot. The majority have a colour temperature of 5800K and are compatible with daylight film and black and white film. Despite the names, swimming pool, soft box, fish fryer, etc. these are really only large or smaller versions of a diffuse light source. The use of an open flash (direct light to subject without diffusion) will give the same effect as a spotlight. Most brands have focusing capabilities and the range of attachments available for tungsten exist in one form or another for use with flash.

Activity 4

Find examples that show the different use of various artificial light sources.
Divide your examples into which you think are tungsten and which you think are flash.
Discuss and compare your selection of images with other students.
Keep in you visual diary for future reference.

Equipment detail

Tripod

A large format camera should always be on a tripod. With a small or medium format camera with exposures longer than 1/60 second, it is advisable to use a tripod. Although an advantage it is not necessary to buy an expensive tripod that can only be used in a studio. A heavy duty tripod that can be used in the studio as well as location, is sufficient. Avoid the many lightweight tripods that are on the market as they will not be stable enough for long exposures. If the tripod is heavy and awkward to carry then it will probably be the right one for studio use. As well as adjustable legs, the tripod should have a head that locks firmly into position at any angle, a rising central column and spirit levels for vertical and horizontal alignment.

Light meter

Working in a studio situation where all light created is from an artificial source it is very important to have a reliable light meter. Next to a camera the light meter is the most important piece of photographic equipment you will own. To fully understand the effect of artificial light and lighting ratios upon film a hand-held meter, capable of measuring both flash and tungsten, with an invercone and reflected light reading attachment is essential. See **"Exposure"**.

Film and Polaroid

There is a overwhelming range of colour film and Polaroid material available to the studio photographer. They can be divided into two types, negative and reversal (positive). This subject guide uses only colour reversal film and black and white Polaroid. Tungsten film (3200K) must be used with tungsten light. Daylight film (5500K) must be used with flash. Black and white Polaroid can be used with either light source. All film and Polaroid should be stored at a constant temperature, as specified by the manufacturer, preferably in a refrigerator. A special back manufactured to fit most cameras has to be attached to the camera in order to use Polaroid. The advantage of this back is that the photograph is taken through the same lens as the final exposure onto film. Using a separate Polaroid camera will not give the same perspective or focal length.

18% grey card

An 18% grey card is an exposure and colour standard introduced by Kodak. It is what all film emulsions are made to truly render at correct exposure. It is important to remember all light meters assume the subject you are about to photograph, in order to give correct exposure is 18% grey. This is referred to as a mid tone or reflecting 18% of the light falling on it. See **"Exposure"**.

First aid kit

All workplaces must comply with Local Health and Safety regulations. The studio environment is no exception. Ensure all lecturers and students know where the First Aid Kit is kept and how to use it, especially with relation to burns. It is imperative that the kit is accessible at all times and not kept locked up in someone's office.

Fire extinguisher

Fire regulations vary from state to state and country to country. Ideally a studio should have a heat activated sprinkler system installed. At the very least Fire Extinguishers should be installed and regularly serviced and maintained. Make sure the extinguisher is appropriate to the risk involved. Ensure all students know where it is kept and how to use it.

Support

A system of reliable support mechanisms are essential for the safe operation of a studio. They can be of a permanent nature or made up from components of the various systems available from a wide range of manufacturers. These stands are commonly referred to as C-stands and come in varying sizes and stability. Again purchase the best you can afford. They can be used for almost any conceivable purpose to support any kind of material used in the photographic process. In combination with gaffer tape and clamps an entire support mechanism can be created.

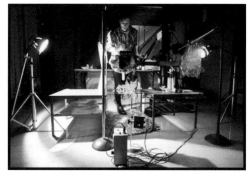

RMIT

Table top-work bench

A ideal surface on which to place most smaller subjects is a table top. Do not interpret this too literally. Any flat, elevated, mobile surface will do.

Tool box

Inevitably a photographer will acquire so much 'junk' in the process of producing images that some type of storage facility will be required. Personal choice will determine what is used but a tool box or fishing tackle box is ideally suited to carry around gaffer tape, clamps, Stanley knife, scissors, Blu-tac, stop watch and heat resistant gloves.

Organisation

The key word to efficient studio photography. Not only does organisation save time but in commercial practice money. Most people at some stage in their photographic career attempt to make money out of photography. To be paid for doing something you enjoy is most peoples' dream. That dream can become hard work through lack of organisation. Organisation in a studio situation covers everything from the simplest task to the most complex. A well-organised studio will operate more efficiently. A place for everything and everything in its place. Look after and maintain your own equipment. Ensure that it works when you most want it to. A tidy, clean studio is also a safer studio. In a studio situation where more than one photographer is working the unexpected will always occur, so be prepared. When working with lights be aware of your position in the studio in relation to others. See **"Art Direction"**.

Pre-shoot checklist

Prior to any photographic assignment a photographer should carry out a simple checking procedure to ensure everything required to produce the photograph is available.

√ Check availability of studio.
√ Check availability of power to studio.
√ Check camera equipment, lenses, lens hood, Polaroid back, tripod, filters, cable release.
√ Check light meter.
√ Check film, type, quantity, expiry date.
√ Check Polaroid, type, quantity, expiry date.
√ Check lighting equipment, spare lamps, cabling, distribution boards.
√ Check availability of diffusion material, reflectors, cutters.
√ Check availability of support mechanisms, table, C-stands, clamps, gaffer tape, etc.
√ Check contents of tool box.
√ Ensure subject matter is in the right place at the right time.

Activity 5

Compile a list of the requirements you would need to photograph a dog, in colour and black and white, in a studio environment using a tungsten light source.
Itemise each piece of equipment, the quantity required, its source and availability.
Compare notes with other students until a comprehensive check list has been achieved.
Keep a record for future reference in your Computation Book.

Revision exercise

Q1. What safety precautions would you take when changing a lamp in a studio tungsten light source?

Q2. What safety measures can be installed into a studio power supply to reduce the risk on injury?

Q3. Two pieces of equipment should be bought to cope with specific emergencies. What are they?

Q4. What is the most important thing to exclude from a studio?

Q5. What is meant by a compound lens?

Q6. How do you estimate what is a normal focal length lens when working with different format cameras ?

Q7. A long lens will give a field of view wider or narrower than a normal lens?

Q8. What device can be used to control the spread of light from a tungsten light source?

Q9. Why does a focal plane shutter have a slower flash synchronisation speed than a between the lens shutter?

Q10. What piece of equipment can be used to reduce lens flare?

Resources

American Cinematographer Manual. ASC Press. Hollywood. 1993.
Basic Photography - Michael Langford. Focal Press. London. 1997.
Encyclopedia of Photography. Crown Publishers. New York. 1984.
The Focal Encyclopedia of Photography. Focal Press. London. 1993.
Kodak Professional Products. Kodak (Australasia) Pty. Ltd. Melbourne. 1998.
Photographing in the Studio - Gary Kolb. Brown & Benchmark. Wisconsin. 1993.
Photography - Barbara London and John Upton. Harper Collins. New York. 1994.
Polaroid Professional Film Guide. Polaroid Australia Pty. Ltd. Sydney. 1998.

Gallery

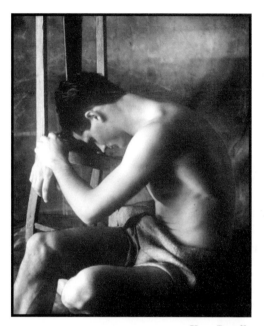

Kate Beadle

Michael Davies

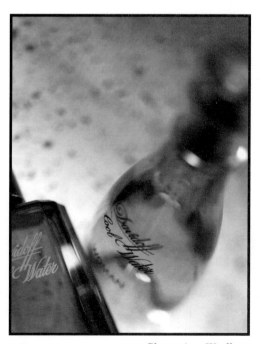

Charanjeet Wadhwa

Soek Jin Lee

Gallery

Hugh Peachey

Chloe Paul

Tejal Shah

RMIT

Light

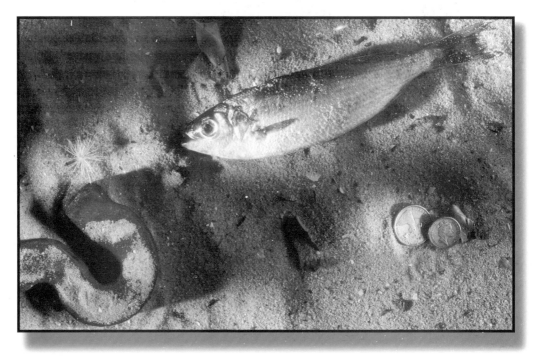

Tejal Shah

Aims

~ To develop knowledge and understanding of how the use of light can create form, dimension and contrast in a studio environment.

~ To develop an understanding of the relationship between artificially created lighting situations and the photographic medium.

Objectives

~ **Research** - Produce a Visual Diary that shows several different studio photographs and the techniques employed to achieve the result.

~ **Discussion** - Exchange ideas and opinions with lecturers and other students on the work you are studying.

~ **Practical work** - Produce photographic transparencies through the use of technique, observation and selection that demonstrate how the direction and the type of light affect the way we view the subject matter.

Introduction

Light is the essence of photography. Without light there is no photography. The major difference between studio photography and any other form is that the studio itself has no ambient or inherent light. This means that unlike photography undertaken in daylight, studio light cannot be observed and interpreted because it does not exist. The photographer starts with no light at all and has to previsualise how to light the subject matter and what affect the light will have upon the subject. It is the fact studio photographers have to previsualise the lighting of the subject rather than observation of what already exists that separates this genre from all others. This requires knowledge, craft, observation, organisation and discipline. Good studio photography takes time, lots of time, and **patience**

Seeing light

In order to make the best use of an artificial light source, we must first be aware of how light acts and reacts in nature. Observation of direct sunlight, diffuse sunlight through cloud and all its many variations will develop an understanding of the two main artificial light sources available. A spotlight imitates the type of light we see from direct sunlight, a hard light with strong shadows and extreme contrast. A floodlight imitates the type of light we see on an overcast day, a soft diffuse light with minor variations in contrast and few shadows. Light falling on a subject creates a range of tones. These fall into three main categories: **Highlights, Mid-tones and Shadows.** Each can be described by its level of illumination (how bright, how dark) and their position and distribution within the frame.

Arthur Sikiotis *Hugh Peachey*

Activity 1

Describe the images above in terms of highlights, mid-tones and shadows.
Draw a diagram for each indicating the relative position of the subject, light source and camera. Discuss and review other students diagrams and opinions.

Artificial light

In a studio situation all forms of light are artificial. All light has to be created by the photographer. An artificial light source can be anything from a large 10kW tungsten lamp to a single candle. Artificial studio lighting was originally measured in candle power, but today light output is measured in watts. A normal household light bulb is 100 watts. A 10kW tungsten-halogen lamp is 10,000 watts.

John Child

Although there has been a resurgence in the use of natural available light for portraiture, the majority of studio photographs are lighted using artificial light sources.
These light sources fall into four categories:

~ **Photoflood**
~ **Tungsten-halogen**
~ **AC discharge**
~ **Flash**

Photoflood

The photoflood is similar in design to the normal domestic lamp. It is correctly balanced to tungsten film and normally used without correction. As the age of the lamp increases a shift in colour balance can occur. This is due to the discoloration of the glass surrounding the element. If used with daylight colour film an orange colour cast will be evident. This can be corrected with the use of a blue (80B) filter. When used with black and white film slight underexposure will occur. As the name implies this type of lamp is used when a broad soft light source is required.

Tungsten-halogen

The most commonly used photographic artificial light. Light is emitted when the element inside the glass envelope is heated and provides a continuous source of light. All tungsten light sources emit a great deal of heat when operating. Unlike the photoflood lamp the glass will not discolour with age and will maintain correct colour balance. Will give correct colour when used with tungsten film. With daylight film a warm orange cast will occur that can be corrected with a blue (80A) filter if correct colour is required. Has no affect upon black and white film other than slight underexposure. These types of lamps are predominantly used in spotlights where a point source of light is required.

AC discharge

Referred to as HMIs, AC discharge lamps have a very high output but emit less heat than tungsten when operating. The design of the light is very similar to the tungsten-halogen spotlight. They are not a continuous light source as the light flickers at very high frequency during operation. This is of no consequence to the stills photographer but must be taken into consideration when exposing moving film. They will maintain correct colour balance throughout the life of the globe and will render correct colour when used with daylight film. When used with tungsten film an orange (85B) filter is required to remove the excess blue that theses lights emit. HMIs are used predominantly in the film industry and in studio car photography.

Hugh Peachey *Tetsuharu Kubota*

Flash

Flash is a generic term that refers to an artificial light source of high intensity and short duration. It will render correct colour when used with daylight film. Used with tungsten film an orange filter (85B) will be required to remove the blue cast. There is minimal heat output, and it maintains constant colour balance and intensity. Flash is not a continuous light source. It has to recycle (recharge) between flashes and has no light output other than at the instant of exposure. To assess the direction and quality of the light flash heads have built in modelling lamps. These are tungsten lamps and not colour balanced to flash. As the output and intensity of the flash is far greater than that of the modelling lamps, exposure times will be too short for any tungsten exposure to register.

Characteristics of light

To understand light it is essential to examine its individual characteristics.

~ **Intensity, reflectance and distance**
~ **Quality, diffusion and reflection**
~ **Colour**
~· **Direction**
~ **Contrast**

Intensity

Intensity is a description of the amount of light falling upon a subject. A hand-held meter with a diffuser attachment will give an incident reading of the light falling upon a subject when the meter is pointed at the light source from the subject. In this way by measuring all the light sources aimed at the subject the **lighting ratio** (the difference between the intensity of light from each source) can be worked out. See study guide **"Exposure"**.

Reflectance

Regardless of the intensity of the light falling on the subject different levels of light will be reflected from the subject. The amount of light reflecting from a surface is called **'subject reflectance'.** The levels of reflectance vary according to the colour, texture and angle of the light to the subject. A white shirt will reflect more light than a black dress. A sheet of rusty metal will reflect less light than a mirror. In all cases the level of reflectance is directly proportional to the viewpoint of the camera. If the viewpoint of the camera is equal to the angle of the light to the subject the reflectance level will be greater. The level of reflected light is therefore determined by:

~ Reflectance of the subject
~ Intensity of the light source
~ Angle of viewpoint and light to subject
~ Distance of the light source from the subject.

Fall-off

The amount of light falling on a subject decreases to a quarter of its original intensity when the light to subject distance is doubled This change in illumination is called fall-off, and is quantified by the 'Inverse Square Law'. For example, if a reading of f16 is obtained when the light to subject distance is one metre, at two metres the reading would be f8, at four metres f4. These rules do not change regardless of the light source.

Quality

Light from a point light source such as tungsten-halogen spotlight is described as having a 'hard quality'. The light will be directional with well defined edges and strong dark shadows. Light coming from a diffuse light source such as a floodlight is described as having a 'soft quality'. The light will appear to be coming from an indiscriminate source with no edges and soft ill-defined shadows of limited density (detail can be seen in them).

Small source = hard light. Large source = soft light.

The quality of light, whether hard or soft, can be changed by diffusion and reflection.

Diffusion

A light source can be diffused by placing certain materials between the light source and the subject. This has the affect of diffusing and spreading the light over a greater area by artificially increasing the size of the source. Relevant to its size, the further the diffusion material from the light source the larger the light appears to be. This softens the shadows, increases shadow detail and decreases the measured amount of light falling on the subject.

Reflection

Light is reflected off surfaces to varying degrees. More light will be reflected off silver than off black. Reflection is a simple way of changing the quality of light. The amount of light reflected off a surface is directly related to subject contrast. A point source of light will give hard shadows to the left side of a subject when lighted from the right. This is called high contrast as there are only highlights and shadows. A reflector used to reflect the light passing the subject back onto the left side would reduce the contrast by raising the detail in the shadows to a level closer to the highlights. See study guide **"Using Light"**.

Activity 2

Load a small format camera (35mm) with tungsten colour transparency film.
Photograph a subject with average tones (another person) under many varied light sources.
Include daylight, domestic lighting, street lighting, commercial and industrial lighting and light sources in your studio.
Keep a record of exposure and light source.
Where known, record output and colour temperature of each light.
Process the film and collate the results with your written record.
Observe how the colour and quality of the light varies from light source to light source and the differences in the reflective levels of elements in the photographs.
Compile this information in your Visual Diary.
Compare and discuss the results with other students and lecturers.
Research the filters required to correct the light sources for use with tungsten film.

Colour

The visible spectrum of light consists of a range of wavelengths from 400 nanometres (nm) to 700nm. Below 400nm is UV light and X-rays and above 700nm is infra red (all capable of being recorded on photographic film). When the visible spectrum is viewed simultaneously we see 'white light'. This broad spectrum of colours creating white light can be divided into the three primary colours: **Blue, Green and Red.**

The precise mixture of primary colours in white light may vary from different sources. The light is described as cool when predominantly blue, and warm when predominantly red. Human vision adapts to different mixtures of white light and will not pick up the fact that a light source may be cool or warm unless it is compared directly with another in the same location.

The light from tungsten-halogen and photoflood lamps consists predominantly of light towards the red end of the spectrum The light from AC discharge and flash consists predominantly of light towards the blue end of the spectrum. The colour of light is measured by colour temperature. Colour temperature is usually described in terms of degrees Kelvin (K). This simply refers to a temperature scale similar to Fahrenheit or Celsius.

Tungsten film is rated at 3200K. Daylight film is rated at 5500K.

To render correct colour, filtration can be used to balance any film to any lighting situation. The filtration required is listed in the manufacturer's specifications packaged with the film.

Light Source	Colour temperature	Film	Filter	Exposure
Average shade	8000K	Daylight	81EF	+0.65
		Tungsten	85B	+0.65
Flash	5800K	Daylight	None	
		Tungsten	85B	+0.65
AC Discharge	5600K	Daylight	None	
		Tungsten	85B	+0.65
Daylight	5500K	Daylight	None	
		Tungsten	85B	+0.65
Photoflood	3400K	Daylight	80B	+1.65
		Tungsten	None	+0.35
Tungsten-halogen	3200K	Daylight	80A	+2.00
		Tungsten	None	
Domestic lamps	2800K	Daylight	80A	+2.00
		Tungsten	82C	+0.65

Direction

Shadows determine the direction of light. They create texture, shape, form and perspective. Without shadows photographs can appear flat and visually dull. A light placed to one side or behind a subject will not only separate the subject from its background but also give it dimension. A front lighted subject will disappear into the background and lack form or texture. In nature the most interesting and dramatic lighting occurs early and late in the day. Observing and adapting this approach is a starting point to understanding the basics of studio lighting.

In some situations front lighting is the only solution to a particular set of requirements, but time should be spent trying to add side or back lighting to any subject.

Tejal Shah *Gary Gross*

Activity 3

Using daylight colour transparency film visit the same location at dawn, midday and sunset. Photograph the effect of the light on the same subject from the same viewpoint each time. Process the film.

Using tungsten colour transparency, or daylight colour transparency with appropriate filtration, attempt to reproduce in the studio the different lighting effects that appear on your transparencies. Use a simple object trying various combinations of studio lights. Compare the quality of the light and comment on the mood that is communicated.

Contrast

The human eye registers a wide range of light intensities simultaneously. Film is unable to do this due to its limited latitude. The difference in the level of light falling on or being reflected by a subject is called contrast. Without contrast photographic images would appear dull and flat. It is contrast within the image that gives dimension, shape and form. Awareness and the ability to understand and control contrast is essential to work successfully in the varied and complex situations arising in studio photography. Contrast can be subdivided into four areas:

~ **Subject contrast**
~ **Lighting contrast**
~ **Lighting ratios**
~ **Brightness range**

Subject contrast

Different surfaces reflect different amounts of light. A white shirt reflects more light than black jeans. The greater the difference in the amount of light reflected the greater the subject contrast. Subject contrast can only be measured when the subject is evenly lighted. The difference between the lightest and darkest tones can be measured in f-stops. If the difference between the white shirt and the black jeans is three stops then eight times more light is being reflected by the shirt than by the jeans.

One stop = 2:1, two stops = 4:1, three stops = 8:1, four stops = 16:1.

Chloe Paul

Laura Humphryis

A **'high contrast'** image is where the ratio between the lightest and darkest elements exceeds 32:1

A **'low contrast'** image is where the ratio between the lightest and darkest elements is less than 2:1.

Lighting contrast

Subject contrast or reflectance range only exists once the studio photographer has turned a light on the subject. Prior to this the subject has no contrast. It is therefore possible to control the subject contrast by controlling the amount of light falling on the subject. If a single point source of light is used to light a subject the difference between the highlights and the shadows will be determined by the amount of light they reflect. Overall image contrast is therefore determined by a combination of subject contrast and **'lighting contrast'**. If we continue with the example of the white shirt and the black jeans an understanding of the difference between subject contrast and lighting contrast can be achieved. A person wearing these clothes when lighted with a large soft diffuse light from the front will have a subject contrast range equal to the reflectance level of the clothes. If you now turn off the front light and light the subject with a point source from the right each item of clothing now reflects different levels of light. The right side of the person is highlighted, the left side of the person is in shadow. When measured this would have a subject contrast range between the lighted side of the shirt and the shadow side of the jeans in excess of 32:1 (high contrast). To control these contrast levels a balance of different light sources are used. This balance is called **'lighting ratio'**.

Lighting ratio

To reduce the lighting contrast levels in the above example the first diffuse light could be moved to the left side of the subject. This has the effect of reducing the contrast between the left and right sides of the subject. This change in the subject contrast can be measured by the difference in the amount of light falling on each side of the subject. The right light measures f32, the left light f16. This is a difference of two stops. Working on the same scale used to measure subject contrast this is a lighting ratio of 4:1. Metering for lighting ratios is covered in greater detail in the study guide **"Exposure"**.

Charanjeet Wadhwa *Thuy Vuy*

Brightness range

Subject brightness range is the combined result of subject and lighting contrast. If a subject with a high reflectance range of 32:1 is lighted by a combination of studio lights having a lighting ratio of 4:1 the overall subject brightness range (SBR) is 128:1.

Subject Brightness Range (SBR) = Reflectance Range x Lighting Ratio.

Film is capable of recording a limited brightness range. A subject photographed in high contrast lighting may exceed this limited range. The ability for the film to accommodate a brightness range is referred to as its **'latitude'**.

Colour transparency film can accommodate a brightness range of 32:1 or five stops latitude. Black and white and colour negative film can accommodate a brightness range of 128:1 or seven stops latitude. With this knowledge the photographer working in colour transparency will understand that any highlight two stops brighter or shadow more than two stops darker than a mid-tone will register little detail. When working in black and white and colour negative the photographer has the increased flexibility to extend this range three stops either side of a mid-tone and still register detail. Specialist processing and printing techniques can extend this range still further.

A subject with a high or extreme brightness range can exceed the latitude of the film

Being aware of the subject brightness range and film latitude allows the photographer to previsualise the outcome of the final image. When the brightness range exceeds the film's latitude the photographer has the option to compensate by increasing or decreasing exposure to ensure shadow or highlight detail. A subject with a high SBR is said to have **'extreme contrast'**.

Extreme contrast

Working in a studio situation where the subject reflectance, lighting contrast and lighting ratio are all under the control of the photographer, extreme contrast is usually by design rather than by any error of judgement. Being aware of film latitude and the photographer's ability to alter lighting ratios to suit the film being used, images with extreme contrast can be avoided. However as all the elements that cause extreme contrast are controlled by the photographer it can be created and used to great effect. Placing highlights in shadow areas and deep shadows through mid tones can create interesting images. Exposure is critical and there is little room for error. Experience and trial and error are the best ways to achieve reliable results.

Joshua Poole

Activity 4

Collect five images that show a subject brightness range from 2:1 to 32:1. Discuss how these ratios were achieved. Is it a dominance of subject reflectance range (SBR), lighting ratio or a combination of both?

Revision exercise

Q1. A subject two metres from a single light source would be correctly exposed at 1/60 second @ f5.6. The subject stays in the same position but the light is moved a further two metres away. Accepting that the output of the light is constant, what would the new exposure time be if the aperture remains at f5.6?

Q2. A subject two metres from a single light source and two metres from the camera would be correctly exposed at 1/30 second @ f8. If the subject to light distance remains constant but the subject to camera distance is doubled, what will the exposure aperture be if the time remains at 1/30 second?

Q3. What filter would a photographer use when using daylight film with a tungsten-halogen light source?

Q4. What exposure compensation will be needed when using an 85B filter?

Q5. If the reflectance range of a subject is four stops or 16:1 and the lighting ratio is two stops or 4:1 what will be the subject brightness range (SBR)?

Q6. Two lights are used to light a subject. The first light (spotlight) is three metres from the subject and measures f16. The second light (floodlight) is two metres from the subject and measures f8. What is the lighting ratio between the two lights?

Q7. Explain the procedure required to reduce SBR when using two artificial light sources.

Q8. If a subject is said to have 'high contrast' would a photographer use colour transparency or colour negative film to achieve the best results?

Q9. Of the four main types of artificial light used in a studio which has a colour temperature closest to the sun at noon on a clear day?

Q10. How would a photographer artificially increase the size of a light source?

Resources

American Cinematographer Manual. ASC Press. Hollywood. 1993.
Basic Photography - Michael Langford. Focal Press. London. 1997
Encyclopedia of Photography. Crown Publishers. New York. 1984.
Kodak Professional Products. Kodak (Australasia) Pty. Ltd. Melbourne. 1998.
Light Science and Magic - Fil Hunter and Paul Fuqua. Focal Press. Boston. 1997.
Photographing in the Studio - Gary Kolb. Brown & Benchmark. Wisconsin. 1993.
Photography - Barbara London and John Upton. Harper Collins. New York. 1994.

Gallery

Gary Gross

Samantha Souter

Exposure

Thuy Vuy

Aims

~ To develop knowledge and understanding of exposure and its relationship to film, depth of field and selective focus.
~ To develop an understanding of the use of a hand-held light meter, the difference between reflected and incident meter readings, and their relationship to lighting ratios and exposure.

Objectives

~ **Research** - Produce research in your Visual Diary that shows an understanding of the affect of exposure in the creation of photographic images.
~ **Discussion** - Exchange ideas and opinions with other students and lecturers on the work you are studying.
~ **Practical work** - Produce colour transparencies through close observation and selection that show an understanding of metering techniques and their relationship to exposure, lighting ratios, depth of field and selective focus.

Introduction

This study guide deals with hand-held light metering techniques **not** TTL (through the lens). Exposure is the amount of light required to correctly expose an image onto film. Exposure is a combination of intensity (the quantity of light determined by the size of the iris) and duration (the quantity of light determined by the length of the shutter speed). Correct exposure is the interpretation of light meter measurements related to the desired effect and the subject being photographed. Too much light will result in overexposure. Too little light will result in underexposure. It makes no difference whether there is a large or a small amount of light the film still requires the same amount of light for correct exposure. Film cannot alter its sensitivity to light and adapt to variations in lighting conditions. Exposure has to be adjusted to compensate for these changes. This is achieved by adjusting either the intensity (**aperture**) or duration of light (**time**) entering the camera. An increase in the size of the aperture will give more exposure, a decrease will give less exposure. A decrease in the duration of the shutter speed will reduce exposure, an increase will give more exposure.

Overexposure *Correct exposure* *Underexposure*

In order to calculate correct exposure the light has to be measured. The device that measures light is called a light meter. All light meters give the photographer information about the amount of light available to obtain correct exposure in f-stops and shutter speeds. These two pieces of information can be used in any combination, For example, an exposure of f11 @ 1/125 second = f8 @ 1/250 second = f16 @ 1/60 second, etc. However, working in a creative medium correct exposure can sometimes be a very subjective opinion.

Exposure is a combination of f-stops and shutter speed - aperture and time.

Activity 1

Find examples of photographs that you think are over, under and correctly exposed. Snapshots are a good example. Discuss why you think this has occurred.
What lighting/exposure situations have you found yourself in where the result has been different to what you expected?

Aperture and time

Aperture

Actual aperture is the size of the diameter of the diaphragm built in to the camera lens. The iris is a mechanical copy of the iris that exists in the human eye. Aperture controls the intensity of the light entering the camera. In the dark the iris of the eye opens up to maximum aperture in order to increase the amount of light reaching the retina. In bright light the iris closes down to minimum aperture in order to reduce the amount of light reaching the retina. In the same way the aperture of the camera lens must also be opened and closed to control the amount of light that reaches the film. The film requires the right amount of light for correct exposure. Too much light and the film will be overexposed, not enough light and the film will be underexposed.

As the aperture on the lens is opened or closed a series of clicks can be felt. These clicks are called f-stops and are numbered. When the value of the f-stop **decreases** by one stop exactly **twice** as much light reaches the film as the previous number. When the value of the f-stop **increases** by one stop **half** as much light reaches the film as the previous number. The only confusing part is that maximum aperture is the f-stop with the smallest value and minimum aperture is the f-stop with the largest value.

The larger the f-stop the smaller the aperture. Easy!

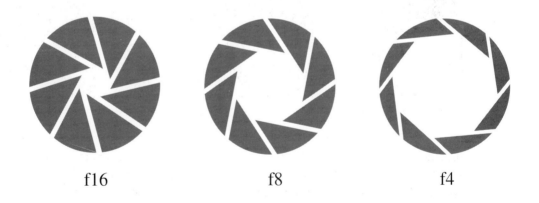

f16 f8 f4

Activity 2

Carefully remove the lens from either a small or medium format camera.

Hold the lens in front of a diffuse light source of low intensity.

Whilst looking through the lens notice how the size of the aperture changes as you alter the f-stop.

Record and discuss the relationship between the size of the aperture and the corresponding f-stop number printed on the barrel of the lens.

Time

The amount of light reaching unexposed film in a camera is controlled by a combination of aperture (f-stop) and time (shutter speed).

Aperture controls intensity, time controls duration.

Until the invention of the focal plane shutter exposure time had been controlled by devices either attached to or within the lens itself. These shutters regulated the length of exposure of the film to light.

Early cameras had no shutter at all and relied upon the photographer removing and replacing a lens cap to facilitate correct exposure times. Other rudimentary shutters, very similar in appearance to miniature roller blinds, were tried but it was not until the invention of a reliable mechanical shutter that exposure times could be relied upon.

As film emulsions became faster so did the opportunity to make shorter exposures. Within a relatively short period exposures were no longer in minutes but in fractions of a second. In a studio situation exposure time related to still life is not a major consideration. Using tungsten light and current film emulsions exposure times of between 1/125 second and thirty seconds are common.

1 second *1/4 second* *1/15 second* *1/60 second*

When photographing people, or anything that is likely to move, with tungsten light an exposure of 1/60 second is usually adequate. Shutters speeds slower than this will almost certainly cause subject movement blur and/or vibration if the camera is hand held and not on a tripod.

With the use of flash, exposure times have little effect upon exposure as the flash is of such high intensity and extremely short duration that camera vibration or subject movement are eliminated.

Activity 3

Load a film with tungsten colour transparency film.

Light an inanimate subject with a diffuse light source (floodlight).

Set the shutter speed on your camera to 1/125 second and the aperture to what is required for correct exposure.

Hand hold the camera and make two exposures at each shutter speed between 1/125 and one second.

Compare and discuss your results with other students to see who has the least image blur.

Light meter

Working in a studio situation where all light created is from an artificial source it is very important to have a reliable light meter. Unfortunately for film manufacturers and photographers the ability of the human eye to compensate for variations in light, shade and contrast is far greater than any of the film emulsions at present on the market. It is therefore difficult to understand the balance of lights (lighting ratio) and their relationship to exposure without the use of a meter.

Next to a camera the light meter is the most important piece of photographic equipment you will own. Other than large format, most cameras have built-in metering systems, but these all work on measuring light reflected from the subject back to the camera. In most cases this will give adequate metering for correct exposure of a subject with average tonal range. It will not tell you the difference in the light falling on different areas of the subject. Without a meter only experience would tell you if there is going to be detail in the shadows or highlights when the film is correctly exposed. The human eye would definitely mislead you.

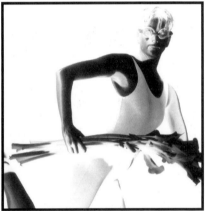

Kathryn Marshall *Kristy Koslowski*

To fully understand the effect of artificial lights and lighting ratios a hand-held meter, capable of flash and tungsten readings is essential. Measuring light for the purpose of exposure can be achieved by taking a reflected or an incident reading of the subject.

A **reflected reading** is when the meter is pointed at the subject from the camera and the light reflected from the subject is measured.

An **incident reading** is when the meter, with diffuser (**invercone**) attached, is pointed at the camera from the subject and the light falling on the subject is measured.

This indicated exposure reading is known as **'meter indicated exposure' or 'MIE'**.

Although the photographer can see the subject in front of him the meter cannot. The meter is calibrated to assume that everything it is pointed at is a mid-tone (grey) regardless of the level of illumination. A meter will therefore give correct exposure for a man in a medium grey flannel suit whether he is in a cellar or sunlight. The mid tone to which all meters are calibrated is called an **'18% grey card'** because it reflects 18% of the light falling upon it.

Using the light meter

There are many ways of understanding the information a light meter is giving in relation to exposure. The meter read-out system itself can be confusing. Some photographers refer to EV (exposure value) readings, others t-stops (transmission) and others in zones. All have their merits and it is better to understand one system well than a little about all. In reality they all mean the same. An understanding of exposure is without doubt the most critical part of the photographic process. Of all the variations the most common usage is f-stops. All meters usually default to f-stops and all camera lens apertures are calibrated in f-stops. It is not important to understand what f-stops are just how they relate to exposure and depth of field.

It is important to understand that if the exposure is increased by one stop, either by time or aperture, the amount of light entering the camera has doubled (2X). If increased by two stops the amount of light has doubled again (4X). If increased by three stops the light doubles again (8X) and so on. This simple law applies with the opposite result to decrease in exposure. It is also important to remember to set the meter to the ISO rating (measure of film sensitivity to light) that applies to the film you are using See **"Film"**.

Incident light reading

An incident reading is when the meter, with invercone attached, is pointed at the camera from the subject and the light falling on the subject is measured. The invercone is a white plastic dome that fits over the meter's light sensitive cell. The invercone accepts the light from a wide field of vision (180°) that is falling on the subject and transmits 18% of that light to the meter's light sensitive cell. The information the meter gives you must then be interpreted into an aperture/time combination.

The meter reading must only be viewed as a guide to exposure. Due to the limitations of film to record the broad range of tones visible to the human eye it is often necessary to take more than one reading to decide on the most appropriate exposure. If a reading is taken in a highlight area the resulting exposure may underexpose the shadows. If a reading is taken in the shadows the resulting exposure may overexpose the highlights. The photographer must therefore decide whether highlight or shadow detail is the priority or reach a compromise.

Activity 4

Take an incident light reading of a subject in a constant light source.

Note the f-stop at an exposure time of 1 second. Increase the number of the aperture by three f-stops.

Note the change in exposure time.

Discuss with other students what the result would be if the duration of time had been increased by a factor of three instead of the aperture.

Which method would be the most appropriate to achieve minimum depth of field?

Reflected light reading.

A reflected reading is when the meter is pointed at the subject from the camera and the light reflected from the subject is measured. This is undertaken with the invercone removed. The meter's light sensitive cell has an angle of acceptance approximately equivalent to a normal lens. With a spot meter attachment this angle can be reduced to five degrees for precise measurements within the subject. The exposure that the meter recommends is an average of the reflected light from the light and dark tones present. When light and dark tones are of equal distribution within the frame this average reading is suitable for exposure. It must be remembered the meter assumes everything reflects light at the same level as an 18% grey card. If the subject is wearing a medium grey flannel suit a reflected reading from the camera would give an average for correct exposure. However if the subject is wearing a white shirt and black jeans a reflected reading of the shirt would give an exposure that would make the shirt appear grey on film. A reflected reading of the jeans would make them appear grey on film. When light or dark tones dominate the photographer must increase or decrease exposure accordingly.

18% grey card

An 18% grey card is an exposure and colour standard manufactured by Kodak. It is what all film emulsions are made to truly render at correct exposure.

It is important to remember all light meters assume the subject you are about to photograph, in order to give correct exposure is 18% grey. This is referred to as a mid tone or reflecting 18% of the light falling on it. If your meter is pointed at a black card it will assume that the card is 18% grey and give an exposure reading that will render the black card grey. This applies equally to a white card. The light meter reading will make the card grey on film. This is why snow comes out grey in thousands of snapshots.

Activity 5

Using a diffuse light source (floodlight) take individual reflected light meter reading of three pieces of card. One white, one black and one mid grey.

The black card should give a reading that is different by four stops to the reading off the white card . The mid grey card should be between the two. If the mid grey card is two stops apart from each, you have a mid-tone that the meter sees as the average tone (18% grey).

Using tungsten transparency film make one exposure of each of the three cards using the meter indicated readings (MIE) of each card.

Photograph the white and black cards again using the meter indicated exposure of the grey card.

Label the results with the meter indicated exposure, the actual exposure and the tone of the card being photographed.

Discuss and compare results with other students.

Lighting ratios

Light meters are often incorrectly called exposure meters. Exposure is only one part of its function. It can also be used for measuring lighting ratios and lighting balance. This is achieved by taking an incident reading of the light source from the subject. The meter is pointed at the light source to measure the amount of light falling on the subject from that specific light. If there is more than one light source each light can be measured independently by ensuring only one light source is on at any one time. In this way the ratios between the light sources can be measured. Understanding and controlling lighting ratios will help ensure that the SBR is within the film's latitude. See **"Light"** and **"Film"**.

Lighting ratios and their relationship to film latitude is best demonstrated and understood at a practical level. Take for example a photographer using colour transparency film known to have a latitude of five stops. To make use of this information the photographer should try to light the subject to within this range. A five stop film latitude would allow a photographer to use a maximum lighting ratio of 32:1 (5 stops). This ratio would retain detail in the highlights and the shadows.

Example 1

In a darkened studio a person is lighted with a single light source from the right-hand side at 90 degrees to the subject. An incident light meter reading is taken from the right hand side of the persons face directly towards the light source. The aperture is f45 at a shutter speed of one second.

An incident light meter reading is taken from the left-hand side of the persons face directly towards the opposite side of the studio to where the light is placed. The aperture is f4 at a shutter speed of one second. This is a lighting ratio of 128:1 (7 stops).

To reduce this ratio another light or a reflector (fill) is placed on the left-hand side of the subject. The fill is moved towards or away from the subject until an aperture reading no more than three stops lower in number than that from the main light source (f16) is obtained. This is now a lighting ratio of 8:1.

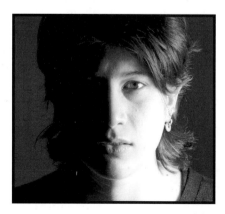

128:1 *8:1*

Example 2

A photographer has to light three sides of a single coloured box with a one stop ratio between each of the sides. Pointing a light meter in the general direction of the subject would give an average reading for 'correct' exposure but would not tell you the difference in the light falling on each of the three sides. This would be achieved by taking either a reflected reading of each side or for a more precise measurement taking an incident reading of each of the three light sources. This would give a measure of the actual amount of light falling on the subject. This information can then be used to adjust the balance of the lights to achieve the required lighting ratio.

1. Spotlight *2. Spotlight + floodlight* *3. Spotlight + floodlight + reflector*

1. A point source (spotlight) is aimed at the top of a neutral grey box from behind the subject. The shadow falls forward of the subject. An incident reading is taken of the light source by pointing the invercone directly at the spotlight. The reading is f16.

2. A diffuse source (floodlight) is aimed at the left side of the box, ensuring that no light affects the top or right side of the box. An incident reading is taken of the floodlight (shield the invercone with your hand to prevent light from the spotlight affecting the reading) by pointing the invercone directly at the floodlight. The reading is f11. This is a lighting ratio between the top and left-hand sides of 2:1 (1 stop).

3. A piece of white card is used to reflect light back into the right-hand side of the box. The light reflected is gathered from the spotlight and floodlight. With both lights on, an incident reading is taken of the reflected light by pointing the invercone directly at the piece of white card. The reading is f8. This is a lighting ratio between the left and right sides of 2:1 (1 stop), and an overall lighting ratio between the top and left-hand side of 4:1 (2 Stops).

To measure exposure an incident reading is taken by pointing the invercone from the front of the box back towards the camera. It should be f11. This is an average of the lighting ratio.

Activity 6

Reproduce **Example 1** on tungsten colour transparency film. Photograph the progressive stages whilst working towards the correct lighting ratio. Process film and compile with all relevant information in your Computation Book. Discuss why the exposure is an average?

Interpreting the meter reading

The information given by the light meter after taking a reading is referred to as the **'meter indicated exposure' (MIE)**. This is a guide to exposure only. As stated before, all meters assume that everything a photographer is about to photograph is a mid-tone and reflects 18% grey. This is hardly ever the case. If you consider interest and visual impact within a photograph is created by the use of lighting and subject contrast (amongst many other things) the chances of all the elements within the frame being a mid-tone are remote. How boring photographs would be if they were. It is up to the photographer to decide on the most appropriate exposure to achieve the result required. A photographer with a different idea and outcome may choose to vary the exposure. It is the photographer's ability to interpret and vary the meter-indicated exposure to suit the mood and communication of the image that separates their creative abilities from others.

Average tones

A subject of average reflectance (mid-tone) is placed with equal dark and light tones. All three tones are lit equally by the same diffuse light source.

A reflected reading of the mid-tones will give correct exposure. A reflected reading of the dark tone will make it grey and overexpose the mid and light tones. A reflected reading of the light tone will make it grey and underexpose the mid and dark tones.

An incident reading will give correct exposure regardless of which tone it is held in front of because it measures the light falling on the subject (in this case the light is equal on all three tones) not the light reflected from it.

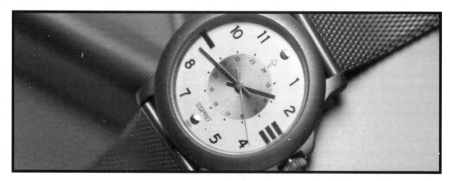

Average tones - Janette Pitruzzello

Activity 7

In a constant light source take a reflected light reading with a hand-held meter positioned 30cm from an 18% grey card. Note the exposure reading.

Now take an incident reading from the grey card with the invercone pointing back towards where you were standing when you took the reflected reading. Note the exposure reading. The incident reading will be the same as the reflected.

The meter with invercone has assumed that the subject is 18% grey.

Dominant dark tones

A subject of average reflectance (mid-tone) is placed with dominant dark tones. All three tones are lit equally by the same diffuse light source. A reflected light meter reading is taken from the camera. The meter will give what it thinks is correct exposure because it has assumed that the subject is reflecting 18% grey. This is not the case however because dark tones dominate. This 'correct' exposure will result in the dark tones becoming a mid-tone and the mid-tone over exposing. If the subject is to be recorded accurately the exposure must be reduced (less time or less light) from that indicated. The amount of reduction is dictated by the level of dominance of the dark tones.

An incident reading will give correct exposure regardless of which tone it is held in front of because it measures the light falling on the subject (in this case the light is equal on both tones) not the light reflected from it.

Dominant light tones

A subject of average reflectance (mid-tone) is placed with dominant light tones. All three tones are lit equally by the same diffuse light source. A reflected light meter reading is taken from the camera. The meter will give what it thinks is correct exposure because it has assumed that the subject is reflecting 18% grey. This is not the case however because light tones dominate. This 'correct' exposure will result in the light tones becoming a mid-tone and the mid-tone under exposing. If the subject is to be recorded accurately the exposure must be increased (more time or more light) from that indicated. The amount of increase is dictated by the level of dominance of the light tones.

An incident reading will give correct exposure regardless of which tone it is held in front of because it measures the light falling on the subject (in this case the light is equal on both tones) not the light reflected from it.

Dark tones *Light tones*

Average exposure

Most films are able to record a full range of tones if the lighting is even and the exposure correct. In most situations where the tones are evenly distributed the most appropriate exposure is often the one indicated by the light meter. When the light or dark tones dominate however, under or overexposure may occur. It is essential that the photographer understands how the light meter reads light to have full control over the exposure.

Exposure compensation

Working in a studio situation, high or low contrast lighting situations are usually high or low contrast because the photographer wants it that way. Exposure compensation would negate the effect the photographer was trying to achieve. When working on location (exterior) the lighting (sunlight) already exists and there is little the photographer can do about it other than exposure compensation. It is this difference that makes high and low contrast situations infinitely more controllable in a studio. Exposure compensation would only be used if the photographer found it impossible to alter either the lighting ratios or subject reflectance range. Assuming this situation could arise, the results of exposure compensation are most easily viewed by using colour transparency film because of its limited latitude. That is to say colour transparency film will over and under expose very easily. The amount of compensation necessary will vary depending on the level of contrast present and what the photographer is trying to achieve. Compensation is usually made in half and one stop increments. This is called **'bracketing'**. Even after compensation the photographer still has the ability to clip test and **'push'** (over process) or **'pull'** (under process) the film if the initial exposure is not as expected. See **"Film"**.

High contrast - Jens Waldenmaier

Activity 8

Place a white object next to a black object.
Light with a single light source so that the light falling on both is equal.
Take a reflected reading and expose one frame at meter indicated exposure (MIE).
Bracket in half stop increments for three stops either side of normal.
Repeat process using an incident reading as MIE. Keep a record of the exposures.
Process the film compare the results with your record of exposures and discuss the results with other students.
What does the meter 'see', and how does the photographer allow for it's limitations?

Assessing the degree of compensation

Photographers calculate the amount of compensation from MIE in different ways. The method chosen is one of personal choice. As accuracy is the primary consideration the method chosen is usually the one with which the photographer is confident and has proved from past experience to be the most reliable.

18% Grey card - Photographers can use a mid-tone of known value from which to take a reflected light meter reading. A mid-tone of 18% reflectance is known as a 'Grey Card'. The grey card must be at the same distance from the light source as the subject. Care must be taken to ensure that the shadow of neither the photographer or the light meter is cast on the grey card when taking the reading.

When using colour transparency or positive film the indicated exposure is suitable for a SBR not exceeding 32:1. If highlight or shadow detail is required the exposure must be adjusted accordingly.

When using black and white or colour negative film the indicated exposure is suitable for a SBR not exceeding 128:1. If the SBR exceeds 128:1 the exposure can be increased and the subsequent development time decreased.

Caucasian skin - A commonly used mid-tone is Caucasian skin. A reflected reading of Caucasian skin placed in the main light source (key light) is approximately one stop lighter than a mid-tone of 18% reflectance. Using this knowledge a photographer can take a reflected reading from their hand and increase the exposure (opening the aperture one stop) to give an exposure equivalent to a reflected reading from an 18% grey card. Further adjustments would be necessary for an SBR exceeding the latitude of the film.

Bracketing - To ensure correct exposure a photographer can bracket the exposures. An incident or reflected reading of a mid-tone is taken. Either side of MIE a photographer can vary the exposure, either by time or aperture, in half stop or one stop increments. The degree of variance does not need to cover the entire SBR.

Polaroid - Working in a studio a photographer has the added advantage of being able to use Polaroid materials to assess exposure and composition. Most film has a Polaroid of similar ISO and comparative contrast range. To best understand the relationship between Polaroid and film testing of both is recommended. This will give you the best correlation between how the correct exposure for film would appear on an equivalent Polaroid. Polaroid film holders (backs) fit most medium and all large format cameras. Polaroid backs suitable for small format cameras are very limited.

Judgement - The best technique for exposure compensation is that of judgement, gained from experience and knowledge. This requires previsualisation of the image and the degree of compensation required to produce the desired effect. This will come with time.

Summary of exposure compensation

Dominant tones

A hand-held reflected light meter reading measures the level of light reflected from the subject. A hand-held incident light meter reading measures the amount of light falling on the subject. The resulting exposure is an average between the light and dark tones present. When light and dark tones are of equal distribution this average light reading is suitable for exposure. When light or dark tones dominate the photographer must increase or decrease exposure accordingly.

Dominant light tones	increase exposure	+	**Open up**
Dominant dark tones	decrease exposure	–	**Stop down**

Extreme contrast

Increase highlight detail	decrease exposure	–	**Stop down**
Increase shadow detail	increase exposure	+	**Open up**

Sophie Takach

Viva Partos

Activity 9

Place a small subject of dominant mid tones one metre from a bright white background. Light with a diffuse light source (floodlight) and take a reflected light reading from the camera position.

Next take a reflected light reading of the subject only.

Test your judgement by determining correct exposure and exposing one frame only.

Creative exposure compensation

Exposure compensation is primarily used to achieve correct exposure. However the creative process of photography sometimes requires an exposure that is **not** correct to produce the desired result. The degree of compensation is only limited by the photographer's imagination and the limitations of the film. Interesting results can be achieved by purposely under or over exposing regardless of SBR.

Colour saturation

Decreasing exposure by 1/3 or 2/3 of a stop will increase colour saturation. This works especially well when using colour transparency film as the processed image is viewed by light being transmitted through the film. Care should be taken when recording tones of known value.

Back lighting

A subject is back lighted when the dominant light is from behind the subject. To take a reflected reading of the subject from the camera would give an incorrect exposure. A reflected reading of the subject only or an incident reading from the subject to the camera would give correct exposure. The dominance of the back light can therefore be controlled by exposure compensation.

Halos

With subjects that have an extreme contrast either as a result of SBR or lighting ratios, exposing for the shadow areas will create the effect of massively overexposing the highlights. On its own or combined with lens filtration (soft filter) the result especially when using a strong back-light is a halo effect around the subject.

Silhouettes

A silhouette is the shadow or outline of the subject against a lighter background. A silhouette can be created by back-lighting the subject and reducing the exposure sufficiently to remove detail from the subject. Reducing the subject exposure by three stops is sufficient to record the subject as black.

Activity 10

Using tungsten colour transparency films create the effect of a halo using a dominant back light and exposure compensation.
Repeat the procedure to create a silhouette.
Record all details.
Process the roll of film and label the results of each frame.

Revision exercise

Q1. A subject two metres from a single light source is correctly exposed at 1/60 second @ f5.6. The light is moved to a new position four metres from the subject. What is the new exposure if time remains constant?

Q2. F8 @ 1/30 second = f5.6 @ 1/60 second = f? @ 1/15 second.

Q3. What degree of exposure compensation would you expect to use when photographing a white subject on a black background?

Q4. True or false? Maximum aperture = f22, minimum aperture = f2.8.

Q5. Is an incident or reflected light meter reading used when balancing lights to achieve a certain lighting ratio?

Q6. Changing exposure from f4 @ 1/60 second to f11 @ 1/60 second has increased or decreased the amount of light entering the camera by how many times?

Q7. A reflected reading measures the light reflecting from a subject. What does an incident reading measure?

Q8. A photographer uses Caucasian skin to establish an exposure reading for a mid-tone. What adjustment should be made to the MIE to correctly expose for the mid-tone?

Q9. What is the lighting ratio of a subject measuring f16 in the highlights and f5.6 in the shadows?

Resources

American Cinematographer Manual. ASC Press. Hollywood. 1993.
Basic Photography - Michael Langford. Focal Press. London. 1997.
Encyclopedia of Photography. Crown Publishers. New York. 1984.
Kodak Professional Products. Kodak (Australasia) Pty. Ltd. Melbourne. 1998.
Light Science and Magic - Fil Hunter and Paul Fuqua. Focal Press. Boston. 1997.
Photographing in the Studio - Gary Kolb. Brown & Benchmark. Wisconsin. 1993.
Photography - Barbara London and John Upton. Harper Collins. New York. 1994.
The Focal Encyclopedia of Photography. Focal Press. London. 1993.

Gallery

RMIT

Russell Shayer

Gallery

Soek Jin Lee

Jana Liebenstein

Romello Fereira

Michael Davies

Film

Kathryn Marshall

Aims

~ To develop knowledge and understanding of the colour films and Polaroid materials available to the studio photographer.

~ To develop an understanding of the use of colour film and Polaroid materials, their advantages, limitations and processing in a studio situation.

Objectives

~ **Research** - Produce a Visual Diary that shows several different studio photographs and the techniques employed by the photographer to achieve the result.

~ **Discussion** - Exchange ideas and opinions with lecturers and other students on the work you are studying.

~ **Practical work** - Produce photographic transparencies through the use of technique, observation and selection that demonstrate a practical understanding of film.

Introduction

There is a overwhelming range of colour film available to the studio photographer. It can be divided into two types. Negative and reversal (positive). This subject guide uses only colour reversal film. This is more commonly referred to as colour transparency. Colour film can only achieve correct colour balance when it is used with the appropriate light source.

~ Tungsten film (3200K) must be used with tungsten light.
~ Daylight film (5500K) must be used with flash or AC discharge lamps.

It is possible however to achieve interesting results by using a film with an incorrect light source. If a daylight film is used with tungsten light a very warm sepia effect is obtained. If tungsten film is used with a daylight source a cold blue effect will be the result. In both cases the ISO value will change resulting in variations to exposure.

The types of colour film suitable for this subject are listed below. They are produced by various manufacturers, who release new materials regularly.

Tungsten

ISO	FORMAT	PROCESS
64	small, medium, large	E-6
160	small, medium	E-6
320	small	E-6

Daylight

ISO	FORMAT	PROCESS
64	small, medium, large	E-6
100	small, medium, large	E-6
200	small	E-6
400	small, medium	E-6

ISO

All film has an ISO (International Standards Organisation) or ASA (American Standards Association) rating.
This rating is a measure of its effective speed (susceptibility to light and contrast).
Using the same light source and exposure aperture, a film with a low ISO (50) will require a longer exposure time than a film with a high ISO (400). In fact it will require eight times more exposure or a three stop increase.

Expiry date

At the time of manufacture all film products have an expiry date printed on their packaging. Do not use film once this date expires. The manufacturer will not guarantee correct rendition of colour and reliable results cannot be predicted. Store unexposed film at a constant temperature, preferably in a refrigerator, but **do not** freeze.

Colour temperature

Colour temperature is a measure of the colour of light. Colour temperature is described in terms of degrees Kelvin (K). This simply refers to a temperature scale similar to Fahrenheit or Celsius. It is not important to fully understand the theory of colour temperature other than to know that certain colour films are used with certain artificial lights. Black and white film is relatively unaffected by colour temperature.

> **Tungsten film is rated at 3200K and used with tungsten lighting.**
> **Daylight film is rated at 5500K and used with flash and daylight.**

To render correct colour, filtration can be used to balance any film to any lighting situation. The filtration required is listed in the manufacturer's specifications packaged with the film. See **"Light"** and **"Film"**.

Reciprocity

Reciprocity, more correctly referred to as reciprocity failure, is a measure of the films ability or inability to handle extreme exposure times. Reciprocity, in general terms, takes effect when shutter speeds are greater than one second when using daylight colour film, greater than thirty seconds when using tungsten colour film and one second when using black and white. All manufacturers issue a technical information sheet with their professional film packaging stating the reciprocity effects and corrections relevant to that batch (manufacturing identification) of film. This should be followed closely.

Without going into the causes of reciprocity the remedy is to reduce shutter speed (time) and compensate by increasing aperture (intensity). Increasing exposure by increasing time will only compound the problem.

The results of not compensating for reciprocity is an underexposed image, varying shifts in colour rendition and unpredictable results.

Activity 1

Using colour transparency film photograph a subject of average subject brightness range. Adjust aperture so exposure times start at 1 second.

In one stop increments, increase exposure time to 64 seconds by aperture/time adjustments. Process film.

Label the results for reference, comparison and discussion.

At what exposure time did the film you chose suffer reciprocity failure?

Positive or negative

Colour or black & white film fall into two main categories.

A positive film emulsion will give you, within its limitations, an image that is exactly what the camera saw. Commercial studio photography reproduced in magazines as advertisements or editorial is predominantly produced on reversal (transparency) film.

The advantage of reversal film is that it is a one step process to achieve a positive image. A negative film emulsion will give you, again within its limitations, an image that is the opposite of what the camera saw. The highlights will be dark, shadows will be light, and colours will appear as their complementary. Red will appear cyan, green will appear magenta, blue will appear yellow and so on (coupled with the fact all these colours are transmitted through an orange film base). It is only when a negative is printed that it becomes a positive image.

The advantage of negative film is its greater '**latitude**' and ability to handle higher contrast levels than positive film.

Processing

Colour film processing should be undertaken by a professional laboratory. Although it is possible to purchase chemicals to process colour film the money saved may well be false economy when considering the experience and equipment required to produce consistent and accurate colour processing.

Colour transparency film is processed by using an E-6 process. This is a Kodak processing system and will process nearly all colour positive films.

Colour negative film is processed by using a C-41 process. This is also a Kodak processing system and will process nearly all colour negative films.

The number of black and white processing systems are as varied as the number of films available. Although not covered in this book it is recommended all photographers develop a thorough understanding of black and white processing. It is relatively simple technology (it has changed little since its introduction) and easy to learn.

Correct exposure

Assessing correct exposure of the processed film can be achieved by viewing the film on a light box or by transmitted light (where the light passes through the film). It takes practice to be precise about the subtleties of under and over exposure but there is a simple starting point. If there is no image detail something is wrong.

If negative film appears 'dense' (transmits very little light) with no visible detail it is probably **overexposed**.

If positive film appears 'dense' it is probably **underexposed**.

If negative film appears 'thin' (transmits nearly all light) with no visible detail it is probably **underexposed**.

If positive film appears 'thin' (transmits nearly all light) it is probably **overexposed**.

Latitude

Latitude is the ability or inability to record detail in subjects with extreme contrast and variation from correct exposure.

It is an accepted rule of thumb that most modern film emulsions have a approximate five to seven stops latitude, although this is sure to increase as manufacturers develop new technology. This means that if you underexposed an 18% grey card by three stops it would appear black on the processed film. If you overexposed it by three stops it would appear white.

The human eye has almost limitless latitude because of its ability to compensate for changes in contrast and light levels. Film is incapable of doing this due to its limited latitude.

Black and white and colour negative films have a latitude of seven stops and can handle a contrast ratio of 128:1. Colour transparency with five stops latitude can handle a contrast ratio of 32:1. The human eye is capable of adjusting to a ratio in excess of 1000:1.

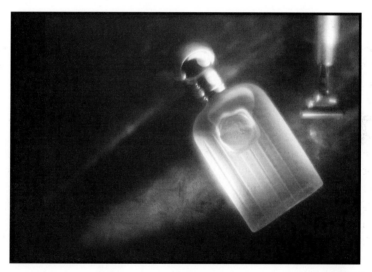

RMIT

Activity 2

Load a camera with tungsten colour transparency film.

Light a grey card with a diffuse tungsten light source.

Make sure the card fills the frame.

De-focus the camera.

Take a reflected or incident meter reading.

Either side of correct exposure, over and under expose in sequence one to five stops.

Process the film.

Evaluate the results. Discuss and compare with other students' results the point at which the film is unable to record detail above and below correct exposure (latitude).

This will indicate the film's latitude and indicate the limit of the film's ability to cope with incorrect exposure.

Push and pull

A safety net that all photographers can use is the manipulation of processing after exposure of the film. This applies to all film stock. Despite the precision of the camera and metering systems used, human error can still occur when taking a photograph.

If the situation allows bracketing (exposure one and two stops either side of and including normal) is a way of ensuring correct exposure. When there is not the opportunity to bracket exposure and all exposures are meter indicated exposure (MIE) it is advisable to clip test the film.

Clip test

Clip testing is a method of removing the first few frames from an exposed roll of film and processing as normal (i.e. to manufacturers' specifications).

If these frames appear underexposed a push process (over processing the film) may improve or compensate for any error in exposure.

If overexposure is evident a pull process (under processing) may correct the result.

The amount of pushing or pulling required to produce an acceptable result is generally quantified in stops. If an image appears under exposed by one stop push the film one stop, over exposed one stop means pull one stop.

Push processing colour transparency that has correct exposure is also an option. It has the affect of cleaning up the highlights and giving an appearance of a slight increase in contrast. Pushing in excess of what would be required to achieve this can be an interesting exercise. The results can be unpredictably dramatic.

Most professional film processing laboratories offer this service.

Normal process *One stop push*

Activity 3

Load a camera with colour transparency film. Deliberately underexpose by one and two stops subjects with average SBR (ratio highlights to shadow 8:1).

Clip test the film - normal process. Clip test again - one stop push.

Clip test again- two stop and three stop push.

Assess the result and process the rest of the film at processing levels you determine.

Keep a record of the results for reference.

Cross processing

Similar to over and under processing is the practice of processing a film in chemicals different to that suggested by the manufacturer.

If a transparency film normally processed E-6 is instead processed C-41 (colour negative) the result is quite different to what would be expected. The result is a transparency with negative colours and tones.

Matching a film to an incorrect process can be done in any combination but the results can vary from amazing to very disappointing, but well worth the experimentation.

It is important to note film speed changes when cross processing. As a general rule transparency film should be under exposed by one stop when processing in C-41, and negative film over exposed by one stop. This is only a guide and variations in film speed and processing should be tested to obtain the result you want.

Colour transparency - process E-6 *Colour transparency - process C-41*

Activity 4

With another student photograph the same subjects of varying SBR (high to low) onto two rolls of colour transparency film.

Bracket the exposures and keep a record of aperture and time.

Process one film E-6 and the other C-41.

Label the results for reference, comparison and discussion.

Polaroid

Since its introduction in 1946 Polaroid film has become a common tool in the assessment of exposure, contrast, composition and design. To most people, whether it be you, a lecturer, an art director or someone wanting a family portrait it is the first evidence of the photographic process and an indicator of where improvements can be made. Polaroid has become 'the rough drawings' on the way to the final photograph. All Polaroid materials, colour or black and white will give a positive image. In some cases a negative, as well as a positive, will be produced that can be printed in the normal way at a later date.

When using Polaroid materials follow the instructions relating to film speed (ISO or ASA) closely and observe the processing times relating to room temperature. It is important processing times be followed carefully.

When assessing a Polaroid image for exposure relative to another film type it should be realised that more detail will be seen in a correctly exposed colour transparency than will be seen in the Polaroid's positive reflective print. This is because transparencies are viewed by transmitted light and prints by reflective light. The Polaroid image will appear 'thin' if it is over exposed and 'dense' if it is under exposed. Types of Polaroid film suitable for this subject are listed below.

Tungsten

TYPE	ISO	FORMAT
Polacolor 64 Tungsten	64	3 1/4 x 4 1/4" 4 x 5"
Polapan Pro 100	64	3 1/4 x 4 1/4" 4 x 5"

Daylight

TYPE	ISO	FORMAT
Polacolor Pro 100	100	3 1/4 x 4 1/4" 4 x 5"
Polapan Pro 100	100	3 1/4 x 4 1/4" 4 x 5"

Activity 5

Using a diffuse tungsten source light a persons hand.

Correctly expose by incident reading onto Polaroid Pro 100 rated to the appropriate ISO for tungsten.

Repeat onto colour transparency film (64 ISO) using Polaroid as your means of determining exposure and composition.

Revision exercise

Q1. Colour reversal film gives a positive or negative image?

Q2. Tungsten transparency film is will give correct colour when used with which light source?

Q3. What is the colour temperature of that light source?

Q4. The exposure for film rated at ISO100 is 1/15 second @ f8.
 What will the exposure be for film rated at ISO 400 if aperture remains constant?

Q5. What is the most likely affect of using out of date colour film?

Q6. Explain what the latitude of film refers to.

Q7. Processing reversal film in a negative process will give what result?

Q8. If a processed negative film is almost totally clear is it over or underexposed?

Q9. Push processing film can be used when the film is over or underexposed?

Q10. Which has the greater latitude, colour negative or colour reversal film?

Resources

American Cinematographer Manual. ASC Press. Hollywood. 1993.
Basic Photography - Michael Langford. Focal Press. London. 1997.
Encyclopedia of Photography. Crown Publishers. New York. 1984.
The Focal Encyclopedia of Photography. Focal Press. London. 1993.
Kodak Professional Products. Kodak (Australasia) Pty. Ltd. Melbourne. 1998.
Light Science and Magic - Fil Hunter and Paul Fuqua. Focal Press. Boston. 1997.
Photographing in the Studio - Gary Kolb. Brown & Benchmark. Wisconsin. 1993.
Photography - Barbara London and John Upton. Harper Collins. New York. 1994.
Polaroid Professional Film Guide. Polaroid Australia Pty. Ltd. Sydney. 1998.

Gallery

Tori Costello

Tetsuharu Kubota

John Child

Creative Controls

Jana Liebenstein

Aims

- ~ To increase knowledge and understanding of aperture, shutter speed and focal length and their combined effect on visual communication.
- ~ To increase familiarity and fluency of operating camera equipment.

Objectives

- ~ **Research** - Produce work in your Visual Diary that shows different studio photographs and the creative techniques employed by the photographers to achieve the results.
- ~ **Discussion** - Exchange ideas and opinions with other students about the work you are engaged in.
- ~ **Practical work** - Produce images that demonstrate a working knowledge of depth of field, timed exposures and perspective.

Introduction

The choice, arrangement and design of a subject within the frame determines the effectiveness of its communication. Communication can be increased by having a better understanding of the camera and its controls. Careful consideration is advised when using technical effects, so the resulting images are about communication and content and not predominantly about technique. Technique should never dominate the image.

The main techniques (other than lighting) employed by photographers to increase communication are:

~ **Focus**
~ **Duration of exposure**
~ **Perspective**

Erik Soh

Familiarity

Owning the latest equipment will not necessarily make you a better photographer. Familiarity with a simple camera used over a period of time can be of far more value. Using the camera must become second nature to the point where it can be operated with the minimum of fuss. The equipment must not interfere with the function of seeing.

The camera is the tool used to communicate the photographer's vision.

Creative photography is about observation and interpretation.

Focus

'**Focus**' is the point at which an image is sharp or is the 'centre of interest'. When framing an image the lens is focused on the point of interest to the photographer. The viewer of an image is instinctively drawn to this point of sharp focus. This is the '**point of focus**' of the image. In this way the photographer 'guides' the viewer to the same point of focus and thereby the same point of interest visualised in the original composition.

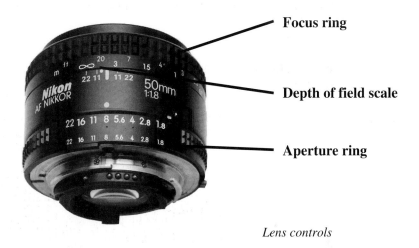

Lens controls

Limitations

Everything physically at the same distance as the focal point of the image will be equally sharp. Subjects nearer or further away are progressively less sharp. The focusing ring on the lens of small and most medium format cameras can be rotated between two points to achieve focus. As the camera moves closer to the subject a point is reached where the subject can no longer be focused by rotation of the focusing ring. This is the '**closest point of focus**', and the lens will be at its greatest physical length. As the camera moves away from the subject the focal point of the image will change until it reaches a point where almost everything within the frame will be sharp. At this point the limit to rotation of the focusing ring will have been reached and the lens will be at its shortest physical length. This distance is called '**infinity**' and is marked on the lens by the symbol ∞. The closest point of focus and infinity will change between different lenses.

Activity 1

Record the closest focusing distance of all your lenses.
With a zoom lens record the closest focusing distance at the shortest and longest focal length.
Using the closest focusing distance of each of your lenses photograph the same object from the same viewpoint
Process the film and record the difference in the images in your Computation Book.

Depth of field

Aperture not only controls exposure, it also controls depth of field. Depth of field is the distance between the nearest and furthest points in focus at a chosen aperture. At maximum aperture the depth of field is said to be narrow (shallow focus). At minimum aperture the depth of field is said to be wide (deep focus). The greatest depth of field is achieved at minimum aperture. If exposure time has to remain constant due to subject limitations then aperture has to be altered to achieve correct exposure. Changing aperture will increase or decrease depth of field depending upon the f-stop used. The larger the number of the f-stop the greater the depth of field. The smaller the number of the f-stop the smaller the depth of field. Depth of field is however relevant to the point of focus. A general rule of thumb is depth of field increases 1/3 forward and 2/3 behind the point of focus as you decrease the size of the aperture (increase the f-number).

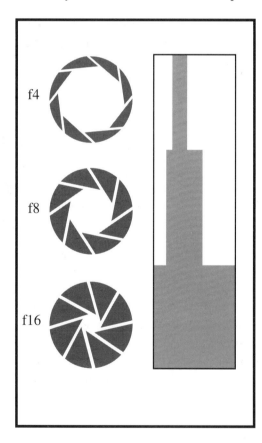

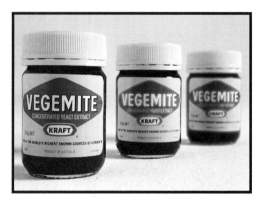

Shallow focus

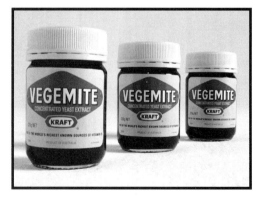

Deep focus

Activity 2

Find and discuss examples of photographs where depth of field has been used as a creative tool in the composition of the image.
Retain photocopies for future reference.

Factors

Depth of field is determined by the distance from the camera to the subject, the focal length of the lens and the size of the aperture.

Distance - As the camera **moves closer** to the subject the depth of field **decreases** (shallow focus). As the camera **moves away** from the subject the depth of field **increases** (deep focus).

Focal length - As the focal length of the lens increases (long lens) the depth of field becomes narrower. As the focal length of the lens decreases (wide angle lens) the depth of field becomes wider.

> **The least depth of field is achieved using the minimum focusing distance at maximum aperture on a long lens. The greatest depth of field is achieved using the maximum focusing distance at minimum aperture on a wide angle lens.**

Point of focus - In most cases depth of field extends unequally in front and behind the point of focus. Focus increases in the proportion of one third forward of the point of focus and two thirds behind.

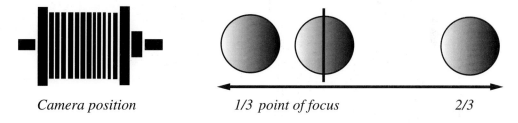

Camera position 1/3 point of focus 2/3

Depth of field

Practical application

All factors effecting depth of field are working simultaneously. Aperture is the main control over depth of field. In combination with framing, composition, lens choice and the distance of the camera from the subject the focal point of the image can be precisely controlled. Using any combination of these techniques a photographer can isolate or integrate that part of the subject within the frame determined to be the focal point of the image.

Activity 3

Record and compile in your Computation book the depth of field distances as indicated on your lenses.

Correlate distances with f-stops from the depth of field scale and retain for future reference.

On which lens does depth of field increase at the greatest rate?

Selective focus

Aperture places limitations upon a photographer that can become a creative advantage with the use of selective focus. This does not mean the camera is focused at a single point to achieve selective focus. When aperture is increased or decreased the depth of field changes. This changes the area of sharp focus to a greater or lesser extent. It is the conscious decision made by a photographer to use a combination of focus and aperture to create a selective field of focus that draws the observers' viewpoint to one area or selected areas of the image.

Samantha Sagona *Kathryn Marshall*

Shallow focus is obtained at maximum aperture (iris wide open) and deep focus is obtained at minimum aperture (iris closed down). Having this information enables the photographer to use this technique to create well defined areas of focus and attention. See **"Exposure"**. In practical terms, this means if a point of focus is chosen and maximum aperture is used for exposure, all areas other than the point in focus will remain out of focus when the camera makes that exposure. As depth of field increases selective focus decreases.

The effect of aperture on depth of field and its use in deciding upon an area of selective focus can be seen prior to exposure by the use of the camera's preview mechanism.

Activity 4

Load a camera with tungsten colour transparency film.
Place two objects one behind the other approximately one metre apart.
Focus with a normal lens on the front object at maximum aperture and make an exposure at every f-stop until you reach minimum aperture. Focus on the rear object and repeat the sequence. Process the film and compare and discuss the results with other students.
Retain for future reference in your Computation Book.

Preview

Most cameras or their associated lenses have the facility to preview an image at the chosen aperture prior to exposure. In one form or another this is achieved by manually closing down the lens (reducing the size of the iris) in order to preview the image using the aperture at which the film will be exposed.

All modern cameras view images at maximum aperture. Even though the f-stop setting on the lens may not be at maximum aperture the viewing system overrides this setting. This allows the photographer to compose the shot with the brightest image available. This can only be obtained by having the lens at maximum aperture whilst viewing and automatically stopping down to chosen aperture at the instant of exposure. This gives the advantage of bright viewfinder images but does not give a true picture of what will be in or out of focus other than the point at which the camera is already focused. Previewing depth of field and its effect upon selective focus is a skill that photographers often use. If the image has been previewed then there can be no surprises when the results come back from processing.

Viva Partos

On most cameras it is possible to change aperture, and see the effect upon depth of field, whilst holding down the preview button. With large format cameras there is no preview button. Viewing the effect of aperture upon depth of field is undertaken by progressively closing down the f-stop from maximum to minimum aperture whilst looking through the back of the camera with your head under a dark cloth to obscure all light.

In all cameras as you close down the aperture in preview mode the image will become darker, halving in intensity every f-stop.

Activity 5

Practice using the preview button on your camera.

Take note of how the image becomes darker as you move through maximum to minimum aperture and the effect it that has upon an area of selective focus.

Discuss the difference between depth of field and selective focus.

Duration of exposure

All photographs are time exposures of either shorter or longer duration. In a studio situation the majority of subjects being photographed will be relatively inanimate. The longer exposure times required for tungsten lighting compared to exterior daylight exposures are usually not a problem. When working with people most professional models can hold poses without significant movement for at least one second. If the photograph is a studied portrait or recreation of a 'period look' the use of an aperture at or close to maximum will give acceptable results and compliment the overall design.
By deliberately choosing long exposures moving objects will record as blurs. This effect is used to convey the impression or feeling of motion. However much of the information about the subject is sacrificed to effect. See **"Using Light"**.

Fast shutter speed

When working in a studio fast shutter speeds would only be required when photographing moving subjects or subjects that are likely to move. Animals and children immediately spring to mind. A shutter speed faster than 1/125 second would be required to freeze their action in order to obtain a sharp image. This does not refer to focus but to image blur. Exposures this fast are most easily achieved using a flash light source of high intensity and short duration. See **"Using Light"**.

Slow shutter speed

When using tungsten light and a shutter speed slower than 1/30 second movement is no longer frozen but records as a streak across the film. This is called movement blur (when using flash the subject will be frozen at any shutter speed). With the camera on a tripod the moving subject will blur but the background will remain sharp. If the camera is panned (the camera follows the moving subject) the subject blur will be reduced and the background will blur in the direction of the pan.

Camera shake

Image blur caused by camera movement can be eliminated by mounting the camera on a tripod and using a cable release to activate the shutter. This is imperative with the longer exposure times required for tungsten light sources. When using flash, camera vibration is not an issue as the duration of the flash is shorter than the fastest shutter speed on the camera.

Activity 6

Load a camera with tungsten transparency film.
Set a metronome (or other constant velocity device) to 4.4 time.
With the camera on a tripod photograph the movement at every shutter speed on your camera. Process the film and compile the results in your Computation Book.

Perspective

Visual 'perspective' is the relationship between objects within the frame and their place within the composition. It is this relationship that gives a sense of depth in a two-dimensional photograph. **'Diminishing perspective'** is when objects reduce in size as the distance from the camera to that object increases. **'Converging perspective'** is when lines that in real life are parallel appear to converge as they recede towards the horizon. The human eye has a fixed focal length and a perspective determined by viewpoint. Photographic perspective can be altered by changing the distance of the camera from the subject.

Steep perspective

A wide angle lens apparently distorts distance and scale, creating 'steep perspective'. A subject close to the lens will look disproportionately large compared to its surroundings. Objects behind and to the side of the main subject will appear much further away from the camera due to the closer viewpoint often associated with a wide angle lens.

Steep perspective

Compressed perspective

The more distant viewpoint of a long lens condenses distance and scale, creating 'compressed perspective'. A subject close to the lens will look similar in size to other subject matter. Objects behind and to the side of the main subject will appear closer together than reality.

Compressed perspective

Revision exercise

Q1. How far into a subject would a photographer focus to maximise depth of field?

Q2. When selecting depth of field what techniques other than aperture could the photographer use?

Q3. What mechanism on a camera allows a photographer to judge depth of field at exposure aperture?

Q4. What would be the slowest shutter speed recommended to stop image blur?

Q5. How can a photographer eliminate camera shake in a studio situation?

Q6. A normal lens will give you steep or compressed perspective?

Q7. The closest point of focus is achieved when the lens is at its longest or shortest physical length?

Q8. Deep focus is obtained at maximum or minimum aperture?

Q9. The greatest depth of field is achieved using which aperture with which focal length lens?

Q10. Selective focus is best achieved at maximum or minimum aperture?

Resources

American Cinematographer Manual. ASC Press. Hollywood. 1993.
Basic Photography - Michael Langford. Focal Press. London. 1997.
Encyclopedia of Photography. Crown Publishers. New York. 1984.
Kodak Professional Products. Kodak (Australasia) Pty. Ltd. Melbourne. 1998.
Light Science and Magic - Fil Hunter and Paul Fuqua. Focal Press. Boston. 1997.
Photographing in the Studio - Gary Kolb. Brown & Benchmark. Wisconsin. 1993.
Photography - Barbara London and John Upton. Harper Collins. New York. 1994.
The Focal Encyclopedia of Photography. Focal Press. London. 1993.
The Image - Michael Freeman. Collins Photography Workshop. London. 1990.

Gallery

Dianna Snape

Michael Davies

Jana Liebenstein

Jana Liebenstein

Gallery

Antonius Ismael

Samantha Sagona

Charanjeet Wadhwa

Using Light

Michael Davies

Aims

~ To develop knowledge and understanding of the use of artificial light sources, camera and associated equipment in a studio environment.
~ To develop an awareness of the effect of artificial light in the creation and control of lighting ratios, shade, contrast and exposure.

Objectives

~ **Research** - Produce a Visual Diary that contains all the reference gathered in completing the activities, and all visual information that influenced the approach taken when producing the photographs for each activity.
~ **Discussion** - Exchange ideas and opinions with other students and lecturers related to the photographs you intend to research and produce.
~ **Practical work** - Produce photographic colour transparencies of the still life, portraiture and fashion assignments.
Compile a computation book giving all information relevant to the technique and production of each photograph.

Introduction

This study guide should be used as a practical source of information to understanding the use of tungsten light sources in a studio situation. The explanation of how to use the two light sources (floodlight and spotlight) around which this study guide is centred is directly related to providing practical lighting solutions to the assignments in the study guides **"Lighting Still Life"** and **"Assignments"**. Completion of the activities will provide a basis for an understanding of the recommended approach to each assignment. It is advisable that the technique and lighting approach suggested in each activity be followed at a group level with all students helping to recreate a single lighting set-up. Upon completion individual students should then adapt the result to their own subject matter.

Dianna Snape *Gary Gross*

Approach

The sun, the dominant light source in the world outside the studio, is the starting point in understanding studio lighting. As you progress through your photographic career other approaches will inevitably influence you but an understanding of how to use a single light source to achieve many varied results is a discipline worth mastering. Try not to attempt too much too soon. Set yourself goals you know you can achieve within your limitations. Students never have enough time or money but admirably they are exploding with ideas. It is making these ideas work within the constraints and abilities of each student that will give successful results. Set out to achieve what you know is possible, use all the time available and exercise **patience**. If three hours is allotted for practical studio classes use the full three hours. If you think you have the shot completed early try variations in the remaining time. Every time you move a light or alter its quality you will learn something. You will never take the perfect photograph. If you think you have then change careers because photographically the learning process has ceased.

Working with studio lights

Common rules

Common rules of physics apply to the use of artificial light sources. When sunlight passes through greater amounts of particles in the atmosphere at dawn or sunset, exposure times increase compared to a reading taken at noon. This applies to clear and overcast days. Exposure times will obviously be shorter on a clear day. Applying these rules to a studio situation, the greater the impedance to the light (diffusion, reflection, filtration) the longer the exposure. Direct light (no diffusion, reflection, filtration) the shorter the exposure.

Another simple rule. The amount of light falling on a subject decreases to 1/4 of its original intensity when the light to subject distance is doubled, and increases by four times when the light to subject distance is halved. For example, if a reading of f16 is obtained when the light to subject distance is one metre, at two metres the reading would be f8, at four metres f4. These rules do not change regardless of the light source. It is also important to remember that contrast in a studio situation is created not only by the reflectance level of the subject matter (SBR) but also by lighting ratios. When referring to lighting ratios the photographer is also referring to lighting contrast. See **"Light"**.

Light one metre from subject-f16 *Light two metres from subject-f16*

Activity 1

In a darkened studio place a floodlight one metre from the studio wall and take an incident reading, with the light on, of the light falling upon the wall.

Note the reading and move the light on the same axis another one metre, making a total of two metres away from the wall.

Note the reading. Double the distance once more, making a total of four metres.

The final reading will be four stops less than the first.

What will the distance of the light from the wall have to be to achieve a meter reading of three stops less than the first?

Tungsten

Vacuum tungsten lamps and their derivatives, are widely used forms of artificial photographic lighting in photography, film and television. They have a colour temperature between 3200K - 3400K and are compatible with Tungsten colour film and any black and white film. See **"Film"**. Despite the extensive use of flash in a commercial studio, prior to any flash exposure the way a subject is lighted has been determined by the use of tungsten modelling lamps built into the flash heads. The flash gives a much shorter exposure time but little advantage in the quality of light over the same subject having been lighted by the appropriate tungsten light sources. Compared to flash, tungsten is simple technology and the cheapest form of artificial photographic light available. It is therefore the ideal light source with which to learn studio lighting in an educational studio situation. It should be taken into account when learning the use of tungsten lighting that all film and television lighting is tungsten based. There are many variations upon the two basic tungsten light sources, but in general terms they all fall in to the two major categories, floodlight and spotlight.

Floodlight

A floodlight produces a wide flood of light across a subject. The light from the lamp bounces off the reflector in which it sits and travels forward as a broad light source. This diffuse light gives 'soft' edges to the shadows and some shadow detail. The quality of the light is similar to that of sunlight through light cloud.

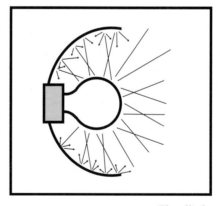

Floodlight

Activity 2

In a darkened studio place a tungsten floodlight four metres in front of a person stood against the wall. Turn on the light. Note the lack of shadow detail behind the person. Without moving the light get the person to move one metre away from the wall. Note the increase in shadow detail and softening of the shadows edges.
Repeat in one metre increments until the subject is almost in front of the light.
What is happening to the shadows and why?

Spotlight

A spotlight, by use of a focusing (Fresnel) lens, can concentrate light at a certain point. The light from the lamp is directed forward by a spherical reflector and focused to a point by the glass Fresnel lens. The light will have 'hard' edges to the shadows and no detail in the shadow areas. The quality of the light is similar to direct sunlight. Spotlights can be 'flooded' to give a more diffuse quality comparable to the spread of a floodlight but with less shadow detail. This change from spot to flood is achieved by moving the lamp and the reflector inside the lamp housing away from (spot) or closer to (flood) the lens at the front of the light. On 'full spot' shadows are harsh with no detail, on 'full flood' shadows are softer with some detail.

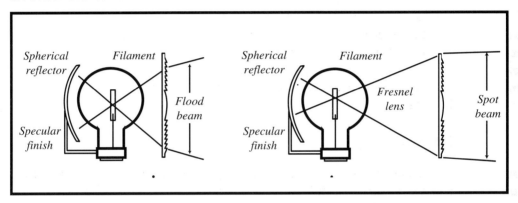

Full flood/full spot

Most spotlights come with barn doors and nets. Barn doors are four metal flaps attached to the front of the light and used to control the shape and amount of light falling on the subject. Narrowing the doors will reduce the amount of light falling on the subject and shape the light to resemble that formed by the barn doors. Once shaped the barn doors can be rotated independently of the main light housing. Nets are pieces of wire gauze of varying densities that reduce the output of the light by diffusing the light at its source without greatly affecting the shadows. They are manufactured in half and one stop increments.

Activity 3

In a darkened studio light a subject (a person) with a floodlight from the right-hand side. Record on colour transparency film with correct exposure for the lighted side of the face. Turn off the floodlight and light the same subject from the same direction with a spotlight on 'full spot'.
Record on colour transparency film with correct exposure for the lighted side of the face. Turn the spotlight to 'full flood' and repeat the procedure.
Process the film and observe and discuss the differences in the intensity and detail in the shadows.
Which light would you use for no shadow detail and which light would you use for limited shadow detail?

Diffusion

Long before the invention of photography, painters had been diffusing light. Light passing through certain materials created a light with soft shadows that were sympathetic to their subjects. Early writings and drawings of Michelangelo show that his studio had a type of cheese cloth hung over the windows. This diffused the harsh sunlight and filled the studio with a soft light more suitable to painting. Any light source can be diffused by placing certain translucent materials between the light source and the subject. This has the effect of diffusing and spreading the light over a greater area by altering the direction of the light waves. Diffusion softens the edges of the shadows and increases shadow detail. At the same time the measured amount of light falling on the subject is decreased. The amount of diffusion is also determined by where the diffusion material is placed in relation to the light source and the subject. The closer the diffusing material to the light source the less diffuse the light. The closer the diffusing material to the subject the more diffuse the light, the softer the edges of the shadows and the greater the shadow detail. There are many diffusion products manufactured specifically for the photographic market. These are products such as scrim, nets, and silks. Other suitable materials are tracing paper, cheesecloth, and window netting provided they are non-flammable or heat-proof.

Normal spotlight

Diffused spotlight

Activity 4

In a darkened studio light a semi-reflective object (e.g. a tomato) with a floodlight from one side. Place the light approximately 1.5 metres from the subject.
Observe the source of light reflected in the object and lack of shadow detail.
Diffuse the light source with tracing paper (60cm x 60cm) approximately 50cm from the light.
Observe the apparent increase in the size and diffusion of the light source as reflected in the subject, diffusion of the shadow and increase in shadow detail.
Without moving the light place the tracing paper as close to the subject as possible.
The light source has now become the size of the piece of tracing paper. There will be a soft spread of light over most of the subject with the shadow being almost nonexistent.
Repeat this procedure using a spotlight on full spot and then on full flood.
Observe the changes in the light source as you move the light from spot to flood.

Reflection

Reflected light is most often used as a way of lighting areas the dominant light source (key light) cannot reach. An example is the strong shadow created by a spotlight when it is to one side of the subject. To obtain detail in the shadow area light has to be reflected into the shadows. This is called fill light and is achieved by collecting direct light from the light source and redirecting it with a reflector. Reflectors can be any size, from a very small mirror to large polystyrene sheets measuring 3m x 1.5m.

Reflected light can also be used as the key light. When photographing a reflective object, or a very diffuse (soft) lighting effect is required, the tungsten light source can be directed into a reflector. The reflector becomes the light source and no direct light from the tungsten source is directed at or reflected in the subject.

When photographing cars in an exterior situation the car is usually positioned so that sunrise or sunset is behind the car. With the sun below the horizon, the sky above and in front of the car is acting as a giant reflector. This is one approach to lighting cars and reflective objects in a studio.

There are many reflective products available that are manufactured specifically for the photographic market. Other more readily available materials are, white card, grey card, coloured card, silver foil, aluminium foil, and mirrors.

Reflector as fill *Reflector as light source*

Activity 5

Light a person's face with a spotlight on full spot from behind and towards one side. Observe the deep shadows that fall across most of the face.

Using a reflector (white card 1m x 1m) redirect the light from the spotlight falling onto the reflector into the shadow areas of the face.

Using colour transparency film record how the intensity of the light changes as the reflector is moved closer to and further away from the face.

Cover the reflector with aluminium foil and repeat the above activity.

Label and keep results for future reference.

Filtration

Filters alter light quality by selectively transmitting certain colours or by changing the way light is transmitted. A red filter only transmits red light. A blue filter only transmits blue light and so on. A soft focus filter changes the direction of the light in the same way as diffusion material softens a light source. Correction filters alter the colour temperature of the light to make it compatible with the film being used. Neutral density filters reduce the amount of light and therefore exposure from a light source without affecting its colour temperature. Glass, plastic and gelatin filters are used for filtration at the camera lens. The advantage of filtering the light source is that different filters can be used on each of the lights whereas with filtering the camera all light entering the lens will be subjected to a common filter. Filters used upon a light source are made of heat resistant coloured polymer (**gels**) manufactured to specific safety requirements and colour balance. The effect of filtration is obvious and immediate. When working with correctly colour balanced gels, appropriate colour film and correct exposure **'what you see is what you get'**. When using colour filtration with black and white film a simple way of remembering the affect of a certain filter is that it will lighten its own colour and darken all others. Filtration of the camera is normally used for colour correction of the entire image. This may be caused by the light source being incompatible with the film or to remove an excess of one colour inherent in the light source. With camera filtration there will always be some degree of exposure compensation. See **"Film"** and **"Exposure"**.

Un-polarised *Polarised*

Polarising filters are invaluable in the control of unwanted reflections and to produce increased colour saturation. This is because of their ability to selectively transmit polarised light as they are rotated in front of the camera lens or light source. A wide range of 'effect filters' such as graduated and star burst are also available. They can produce some interesting results but should not be used as a substitute for the lack of an original idea or solution to a photographic problem.

Activity 6

Load a camera with colour transparency film. Collect together many different filters. Photograph a subject with an average SBR with and without each filter.
Note exposure, filter used and light source. Compile the results in your Computation Book.

Flash

Flash is a generic term that refers to an artificial light source of high intensity and short duration. It has a colour temperature of 5800K and is compatible with daylight colour film and any black and white film. Unlike tungsten it is not a continuous source of light. Between flashes it has to recycle (recharge) to maximum output before it can be used again. A large tungsten lamp has an output 100 times greater than the average household light bulb. With a film rated at ISO100 this will give exposures of around 1/60 second at f4. A modest studio flash with an output of 5000 joules (measurement of output) at the same distance from the subject will give exposures of around 1/500 second at f11. This is six stops faster or a ratio of 64:1. Its advantage when photographing anything that moves is obvious.

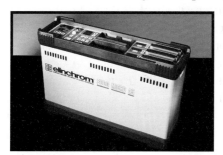
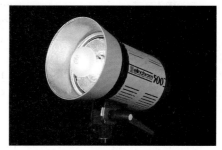

Power pack *Flash head*

The advantage of modern flash is its lightweight construction and versatility. Most studio flash systems consist of the power pack, flash heads and flash head attachments. The power pack is usually a separate unit where the power output is stored until the instant of exposure. After exposure the power pack recharges ready for the next exposure. Recycling times vary from seconds to fractions of seconds. The faster the recharge to full power the more expensive the unit. The flash heads are the actual light source. The basis of their design is to produce light similar to that produced by floodlights and spotlights. The way in which this is achieved ranges from varying sizes of reflector bowls similar in design to a floodlight to a focusing spotlight equivalent to its tungsten counterpart. The choice of flash head attachments is as broad as that available for tungsten light. Apart from some examples of portraiture, all photographs in this book were lighted using tungsten light. This is not to underestimate the importance of flash in a studio situation. Tungsten lighting is however a far less expensive source of studio lighting, more resilient to student use and has lower maintenance costs. The lessons learned with one light source apply equally to any other.

Activity 7

Using various resource materials compile a collection of studio photographs that have used tungsten or flash as a light source. Divide into the two categories.

Discuss with lecturer and other students why that particular type of light source was used, its advantages and the difference in the result if the other type had been used.

Keep all results and comments in your Visual Diary.

Floodlight

Despite the manufacturers names, swimming pool, soft box, fish fryer and many others, these are really only larger or smaller versions of a floodlight. In some the light source is placed inside and to the rear of a collapsible tent with direct light transmitted through a diffuse front surface. In others the light is reflected off a white or silver surface before it is transmitted through a diffuse front surface. These types of light sources give a very soft diffuse light with minimum shadows.

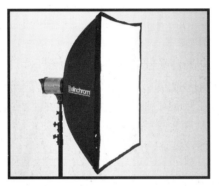

Soft box

Another source of soft diffuse light is created when flash is used in conjunction with a collapsible umbrella. With umbrellas that have a white or silver (inside) surface, light can be directed into the umbrella and reflected back onto the subject. With umbrellas that have a semi-transparent diffuse surface, light can be directed at the subject through the umbrella. This can give a harder light than the reflected light from the white umbrella.

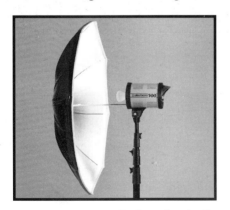

Reflected umbrella *Diffuse umbrella*

Spotlight

The use of an open flash (direct light to subject without diffusion or reflection) will give the same effect as a spotlight. Some brands have focusing capabilities that closely imitate Fresnel spotlights. The light will be hard with no shadow detail. Barn doors, nets and filtration of the light source is approached in exactly the same way as a tungsten source.

Mixed light sources

Any source of light can be combined with another to create interesting lighting effects and shifts in colour balance. In a studio situation this can go beyond mixing tungsten with flash and is limited only by one's imagination. Normal domestic lamps are often used as supplementary and practical sources of light. Candles give a warm glow and very soft shadows. Torch light can be used to great effect when painting with light. When working in colour do not be afraid to change the colour of the light by the use of coloured gels over the lights or filtration of the camera. If it gives off light, try using it!

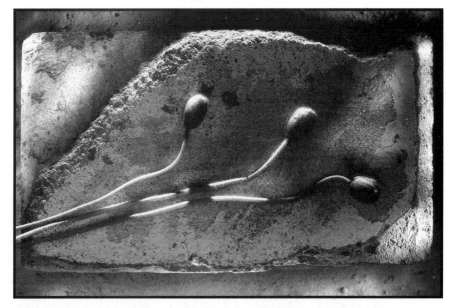

Mahesh Haris

Activity 8

Load a camera with tungsten colour transparency film (64 ISO). Place the camera on a tripod and attach a cable release. Focus on coin placed on a dark background. Set the shutter speed to T (the aperture opens when the cable release is activated and will not close until the cable release is activated for the second time). Set the aperture to maximum aperture. Turn off all studio lights and darken the studio.
Activate the cable release to open the lens.
Using a small torch with new batteries move the light from the torch over the coin as if you were painting it with a brush (large broad strokes) for approximately 10 seconds. This should be done from the camera position.
Bracket your exposures by one stop either side of normal (5 seconds and 20 seconds).
Repeat this procedure at every f-stop.
Note all details and process film.
Compile results and information in your Computation Book.

Illusion of movement

Closely associated with an understanding of the use of light is the use of the camera to create the illusion of movement. By combining the movement of either the camera, subject, or lights the illusion of movement within a still frame can be created. Using tungsten light in a darkened studio and with the camera lens open, walking slowly through frame (the camera's field of view) will result in a blurred image where you were moving and still image where you stopped. Another way to create movement is to increase exposure time to the longest possible with the light source you are using and move the camera during all or part of the exposure. This is easily achieved with a zoom lens, but also achievable by panning or tilting the camera mounted on a tripod. There other advantages to using a slow shutter speed when using a combination of flash and tungsten. If the output of the modelling lamps, or supplementary tungsten lighting, is high enough to equal the exposure aperture of the flash output a slower exposure time can be used for the tungsten light than that required for the flash. This would allow correct exposure of the flash (which is regulated by aperture and not time) and correct exposure of the tungsten (which is regulated by a combination of aperture and time). This would give the effect when using daylight film of a warm after-glow to any object that moved before or after the flash exposure.

Gary Gross

Activity 9

Load a camera with tungsten colour transparency film.
Light a person with a broad diffuse tungsten light source from the same position as the camera.
Set the shutter to the longest exposure possible relative to the aperture.
In a darkened studio with the lens open get the subject to walk around in frame.
Vary the speed and rhythm of the movement.
Process the film and compile results and information in your Computation Book.

Revision exercise

Q1. An incident meter reading of a subject with average SBR two metres from a light source is f11 @ 1/60 second. What will the exposure be at 1/30 second if the light is moved another two metres further away from the subject?

Q2. What happens to the quality and quantity of the light when a spotlight is moved from full spot to full flood?

Q3. What affect does the colour temperature of tungsten light have upon black and white film?

Q4. What is the name given to the shaped piece of optical glass used to bring a spotlight to focus?

Q5. Barndoors can control the shape of a light source. What attachment can control the intensity of the light?

Q6. What are the advantages of diffusing a light source?

Q7. Reflectors are primarily used to provide fill light to unlighted areas of a subject. What is their other important use?

Q8. A red filter will have what affect upon black and white film?

Q9. A polarising filter will have what affect upon tungsten colour film?

Q10. Flash is a non-continuous light source. What does this mean?

Resources

American Cinematographer Manual. ASC Press. Hollywood. 1993.
Arriflex Professional Products. Arriflex Corporation. New York. 1998.
Basic Photography - Michael Langford. Focal Press. London. 1997.
Elinchrom Professional Products. Elinca sa. Renens, Switzerland. 1997.
Encyclopedia of Photography. Crown Publishers. New York. 1984.
Kodak Professional Products. Kodak (Australasia) Pty. Ltd. Melbourne. 1998.
Light Science and Magic - Fil Hunter and Paul Fuqua. Focal Press. Boston. 1997.
Photographing in the Studio - Gary Kolb. Brown & Benchmark. Wisconsin. 1993.
Photography - Barbara London and John Upton. Harper Collins. New York. 1994.
Photographic Lighting - John Child and Mark Galer. Focal Press. London. 1999

Gallery

Dianna Snape

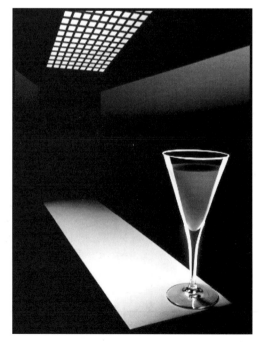

Erik Soh

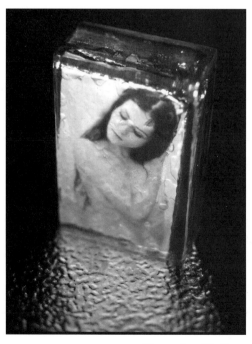

Charanjeet Wadhwa

RMIT

Lighting Still Life

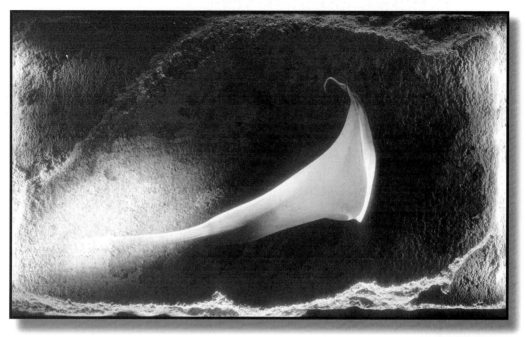

Mahesh Haris

Aims

~ To develop a knowledge and understanding of the application of studio lighting ⸱to still life subjects.
~ To develop an understanding of the practical use of light to create contrast, dimension and mood.

Objectives

~ **Research** - Through thorough pre-production ensure that all the requirements to produce the images are available in the right place at the right time.
~ **Discussion** - Exchange ideas and opinions with other students and lecturers relevant to the assignments being completed.
~ **Practical work** - Produce colour transparencies to the highest standard that fulfil the criteria set down in the assignment information.

Introduction

The assignments in this study guide are written with the assumption the aspiring photographer has a very limited knowledge of the practical application of studio lighting. It is important the assignments are completed in the order in which they are written. Each lesson learnt from one applies to the assignment that follows. To attempt to produce the assignments out of sequence will mean certain information relating to lighting development and metering techniques will be missed. The criteria set out in each assignment should be followed as closely as possible as it forms a major part of the practical learning process. It is advisable that each assignment be workshopped at a group level with guidance and direction from the lecturer. Individual students should then attempt to complete their own interpretation of the brief within a three-hour period.

The assignment brief is itemised into specific requirements. These requirements must be successfully completed as a basis for any assessment of the completed image. Interpretation of the brief beyond these requirements should be encouraged but not at the expense of the basic criteria. All information relevant to the completion of each assignment must be recorded in your Computation Book.

Criteria

Lighting This is a description of the lighting that is required as a minimum starting point to complete the assignment. The recommended use of the light is indicated (direct flood, full spot, fill, etc.) along with its purpose and effect upon the subject (e.g. to create tonal difference).

Props This is a recommendation of other objects that could be used within the image area to enhance the composition and design of the photograph. The use of props is a personal choice dependant upon your previsualisation of the image in your Visual Diary.

Background In the first two assignments the background colour is specifically related to the criteria of the brief. It is difficult to create a foreground shadow of the box on a black background. With the ball assignment it is difficult at this stage of the learning process to control strong backlighting on a white background. In the other assignments the choice of background is limited only by your imagination.

Exposure To develop an understanding of metering techniques follow the method specified in the brief. In the earlier assignments lighting ratios between lights will be asked for (ratio of 2:1 between key light and fill). Lighting ratios are measured with your light meter. See **"Exposure"**.

Technique Technique is the use of all the elements the photographer controls in order to produce the specific requirements laid down in the assignments. This covers the use of the camera, lighting, exposure and composition to create an image that fulfils the brief and compliments the photographer's previsualisation of the image.

Lighting Diagrams

A lighting diagram is a graphic means of illustrating the lighting and camera set-up in relation to the subject. Measurements are not shown as these will vary according to the output of the lights being used and the size of your subject. It is important however to attempt to reproduce the direction and quality of the light. The diagrams are therefore a starting point from which to experiment and build your knowledge. Lighting diagrams should form a major component of your Computation Book.

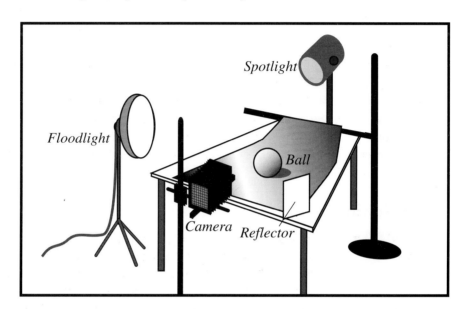

Polaroids

A series of progressive Polaroid images will show the way in which an answer to the individual lighting solutions posed by each assignments is solved. Cost is always a factor in photography, no more so than when a student, so the choice of whether to shoot Polaroid materials as a way of judging exposure and composition is left to the individual. The cost of a few Polaroids can however be far less than having to re-shoot the assignment due to an error that may have been obvious on a progress Polaroid image.

Assignment 1 'Box'

Criteria

Lighting Direct spotlight and floodlight, plus reflector to create tonal difference between the three sides of the box.

Props Optional.

Background White.

Exposure Incident light meter reading. Lighting ratio of 2:1 between spotlight and floodlight and 2:1 between floodlight and reflector.

Technique Create an image of a single coloured box with a foreground shadow and three sides with separate tonal ranges.

Polaroid 1

Place a single coloured box on a white background. Place the camera on a tripod in front of and 30 degrees above the subject. Using a normal lens at maximum aperture focus 1/3 of the way into the top of the box. Fit a lens hood to the camera. From behind the subject aim a spotlight on full spot into the centre of the top of the box. With the light correctly centred turn the spotlight to full flood and move the light so that the shadow falls directly in front of the subject. Ensure that **only** the top of the box is directly lighted by the spotlight. Check for lens flare (direct light into the lens). Take an incident reading of the light source from the subject. Set film ISO and note the aperture.

Polaroid 2

Turn off the spotlight. As viewed from the camera, place a floodlight on the left of the box and at the same distance from the box as the spotlight. Turn on the light and ensure direct light from the floodlight **only** lights the camera left side of the box. Take an incident reading of the light from the subject. Note the aperture and adjust the floodlight by moving it closer to or further away from the subject until an aperture of exactly one stop less light than the spotlight is achieved. This will be a lighting ratio of 2:1 between the spotlight and the floodlight.

Polaroid 3

Turn on both lights. As viewed from the camera place a reflector (piece of white card) on the right-hand side of the box approximately half the distance of the floodlight from the subject. Whilst shielding the invercone with your hand take an incident reading from the subject of the light being reflected from the white card. Move the card closer to or further away from the subject until a reading exactly one stop less light is achieved. This will be a lighting ratio of 2:1 between the left and right sides of the box. After repeating the light measuring sequence take an incident reading from the front of the box directly back to the camera. This will be an average of all the readings and 'correct' exposure. Check focus and select an f-stop (using preview mechanism) that will give sharp focus from the front to the back of the box (depth of field). Make a final check for lens flare before exposing film.

Lighting diagram

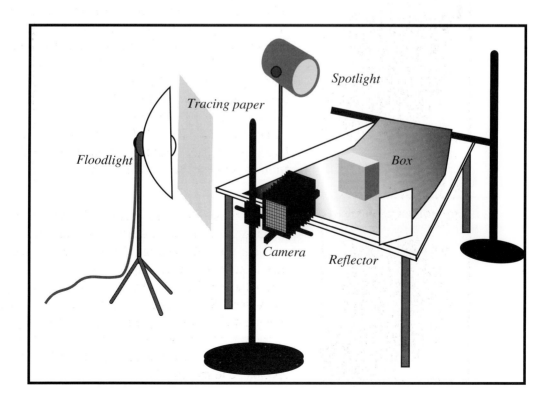

Assignment 2 'Ball'

Criteria

Lighting Direct spotlight and floodlight, plus fill.

Props Optional.

Background Black.

Exposure Incident light meter reading. Measured lighting ratio of 3:1 between backlight and fill light and 2:1 between fill light and reflector.

Technique Using light to create dimension and 'roundness' across the surface of the ball.

Polaroid 1

Place a non-reflective ball on a black background. Place camera on a tripod in front of and slightly above the ball. Using a long lens at maximum aperture focus 1/3 of the way into the ball. Fit a lens hood to the camera. From behind and above the subject aim a spotlight on full spot at the centre of the back of the ball. This will give a rim of back light around the edge of the ball. Move the spotlight so the shadow falls forward of the ball. Ensure only the edges of the ball are lighted by the backlight. Reposition the light if lens flare becomes a problem. Take an incident reading of the light source from the subject. Set film ISO and note the aperture.

Polaroid 2

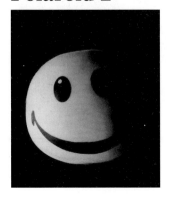

Observe the left side of the ball where the front of the ball falls into shadow. Leave the back light on. Place a floodlight on the left of the ball at the same distance from the ball as the back light. Turn on the light and aim the centre of the light at the line that denotes the change from light to shadow. Pan the light to the right. Observe how the light begins to creep across the front of the ball creating visual curvature. Turn off the backlight. Take an incident reading of the fill light. Move the light until an aperture one and a half stops less light than the back light is achieved. This will be a lighting ratio of 3:1.

Polaroid 3

Turn on both lights. As viewed from the camera place a reflector (piece of white card) on the right-hand side of the ball approximately half the distance of the fill light from the subject. Whilst shielding the invercone with your hand take an incident reading from the subject of the light being reflected from the white card. Move the card closer to or further away from the subject until a reading exactly one stop less light is achieved. This will be a lighting ratio of 2:1 between the left and right sides of the ball. After repeating the light measuring sequence take an incident reading from the front of the ball directly back to the camera. This will be an average of all the readings and 'correct' exposure. Check focus and select an f-stop (using preview mechanism) that will give sharp focus from the front to the back of the ball. Make a final check for lens flare before exposing film.

Lighting diagram

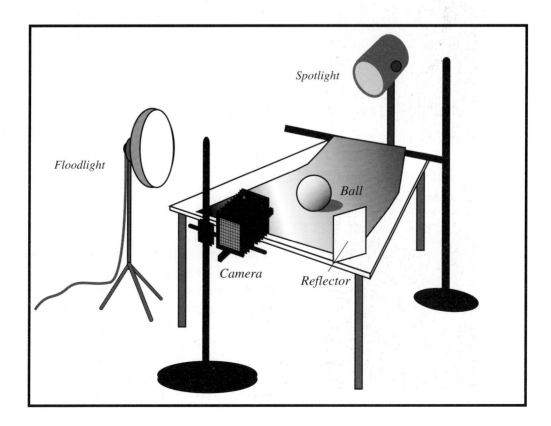

Assignment 3 'Texture'

Lighting Direct spotlight at low angle to subject plus fill. Diffused back light.

Props Minimal.

Background Predominantly the subject or an unobtrusive colour or tone.

Exposure Incident light meter reading. Subjective choice of lighting ratio.

Technique Using lighting contrast to emphasise subject texture and to retain
 detail in the shadows.

Polaroid 1

Support a cane place mat in front of a sheet of tracing paper to form a 'S' shape. Place a spotlight behind the tracing paper with the centre of the light at the bottom of the 'S' shape to create a graduation of light from the bottom to the top of the image. Position suitable support material to form an acceptable composition. Take a reflected light meter reading of the light passing through the place mat and adjust to over expose by three stops. Note this calculated exposure.

Polaroid 2

Turn off the back light. From the camera position place a spotlight above and to the right of the subject. Aim the light at the support material to form shadows and texture across the mat. Alternate the spotlight between full spot and full flood to achieve the desired harsh or soft shadows. Take an incident reading of the light falling on the subject. Adjust the light to achieve the same aperture calculated for the backlight. This will give a ratio of 8:1 between the back light and the front light.

Polaroid 3

Turn on the back light. Make final adjustments to composition, lighting and exposure. Reduce any extreme highlights on any reflective surfaces. To maintain maximum density in the shadows this is best achieved by repositioning the subject and not by diffusing the light. Diffusion would have the effect of almost eliminating the shadows.

Lighting diagram

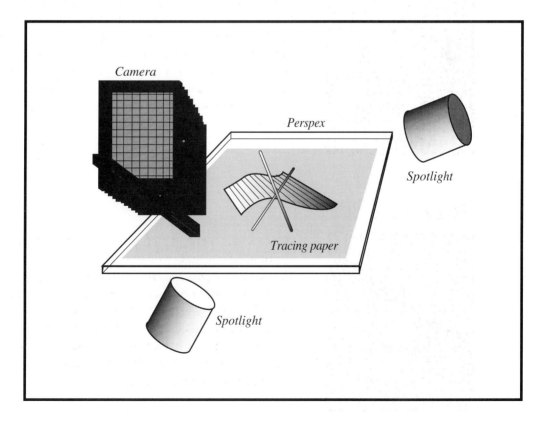

Assignment 4 'Flowers'

Lighting Diffuse key light plus back light to separate subject from background.

Props Minimal and complementary to subject matter.

Background Unobtrusive colour or tone, lighted separately to subject.

Exposure Incident light meter reading. Lighting ratio sympathetic to subject.

Technique Subject in focus. Background out of focus and back lighted separately to foreground subject matter.

Polaroid 1

Place a flower on a sheet of white translucent perspex. Using a floodlight light the perspex from underneath. Centre the light behind the head of the flower. Adjust the light until the desired spread of light is achieved on the background. The background will appear white at the centre of the light graduating to various shades of grey towards the edges. Take a reflected reading of the centre of the light. Increase this exposure by two stops to give a tone that is almost white (e.g. f22 to f11). Record this exposure.

Polaroid 2

Turn off the background light. As viewed from the camera place a spotlight slightly above and to the left of the flower. Between the spotlight and the flower hang a large sheet of tracing paper. Move the tracing paper closer to or further away from the flower until the desired effect is achieved (the light on the subject will be more diffuse the further the tracing paper is from light source). Take an incident reading from the flower of the light falling on the subject. Move the floodlight until a reading the same as the calculated exposure for the background is achieved This will render the flower as 18% grey and the centre of the background nearly white.

Polaroid 3

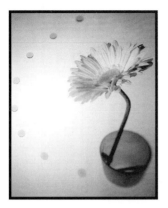

Turn on the background light. Check that the lighting ratio between the background and subject has not changed. Take an incident reading from the flower, back to the camera, of the light falling on the subject. If the flower is of an average mid-tone this will be correct exposure. If the flower is lighter or darker adjust the exposure accordingly, but remember to retain the same lighting ratio between subject and background, two stops or 4:1. Choose an exposure aperture that has sufficient depth of field to retain focus on the flower but no focus on the background.

Lighting diagram

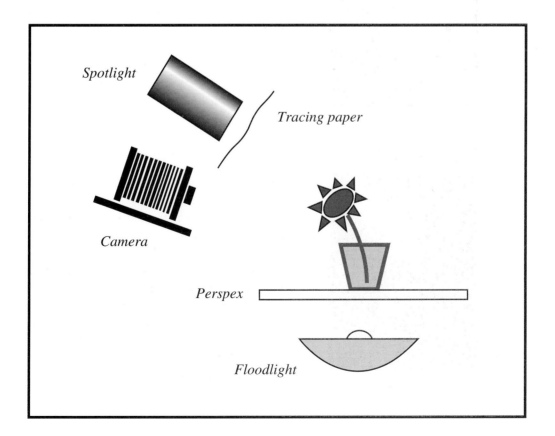

Assignment 5 'Cogs & chains'

Lighting Diffuse/reflected lighting, plus selective fill.

Props Subject related.

Background Coarse and heavily textured.

Exposure Adjusted incident or reflected meter reading of the highlights.

Technique Using light and contrast to enforce the harshness of the subject, whilst
 retaining maximum detail in the highlights and some detail in the
 shadows.

Polaroid 1

Suspend a piece of chicken wire approximately two metres in front of a black background. Hang assorted cogs and chains from the chicken wire. Above this support a large white reflector at right angles to the chicken wire. From in front of and below the camera aim a spotlight on full spot into the reflector. Position the centre of the spot to achieve the maximum reflectance of the light onto the subject. When this has been achieved turn the light to full flood. This will create a spread of diffuse light over the entire subject, but with little contrast between each element. Ensure no light falls on the background.

Polaroid 2

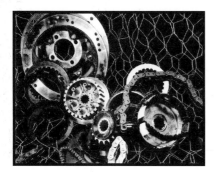

As viewed from the camera position aim a second spotlight, on full spot, from the left side towards the metal cogs. Adjust the direction of the light until the maximum reflectance of the light appears as extreme highlights on the metal surfaces. Ensure no light from the second spotlight falls on the background. The highlights and shadows created by this light will enhance the harshness and contrast of the subject but create unwanted highlights that may be beyond the film's latitude.

Polaroid 3

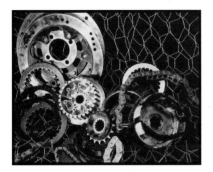

Place between the second spotlight and the subject a sheet of tracing paper or other suitable diffusion material. Move the tracing paper closer to or further away from the subject to reduce the extreme highlights on the metal surfaces. Experiment until the desired effect is achieved. The highlights will appear to spread and become even when the diffusion material is closer to the subject than to the light. To check the subject brightness range take a reflected reading of the highlights and the shadows. If the ratio is less than 32:1 (5 stops) most film will render some detail in both. For exposure take either an incident reading of an area of average illumination or take a reflected reading of an area reflecting approximately 18% grey. Adjust this reading within the 32:1 ratio to achieve the desired result (expose for either the shadows or the highlights).

Lighting diagram

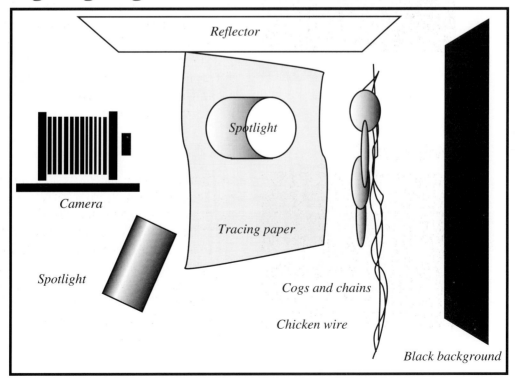

Assignment 6 ' My desk'

Lighting Interpretive use of light as observed in 'real life' e.g. late afternoon sunlight mixed with ambient room light.

Props Self explanatory.

Background The subject matter itself.

Exposure Incident light meter reading of key light area.

Technique Related to your vision of your desk 'correct' subjective exposure of the keylight and detail in the ambient areas. The selective use of aperture and focus together with filtration of the light source or camera to compliment image composition and quality of light.

Polaroid 1

Place the props on an appropriate table top surface. Position the camera to achieve an approximate composition. As viewed from the camera, position a spotlight behind, above and to the right of the table. Turn on the light and centre the light on full spot, on the focal point of the composition (e.g. the coins). Flood and move the light until the desired shadow effect and direction is obtained. Record an incident reading of the light from the subject.

Polaroid 2

Hang a large sheet of tracing paper between the light source and the subject. Cut thin strips from the tracing paper so shafts of direct light appear across the surface of the subject. The intensity of the shafts of light can be controlled by either flooding or spotting the light, moving the tracing paper closer to or further away from the light source, or increasing the size of the cut out strips. Experiment until the desired effect is achieved.

Polaroid 3

Observe there is an obvious difference in the intensity of the light falling on the subject between the diffuse (traced) and direct (non-traced) areas. Adjust camera and subject matter for final composition. Take an incident meter reading of the direct and diffuse areas. Adjust the exposure dependant upon how the highlights and shadows would best enhance the design and balance of the image. Exposure for the direct light will produce under exposed shadows. Exposure of the diffuse light will produce over exposed highlights. Start with an average of the two readings and bracket the exposure. Choose an exposure aperture that will concentrate the viewers interest on the focal point of the image. Interpret the processed results to gain a better understanding of exposure and film latitude.

Lighting diagram

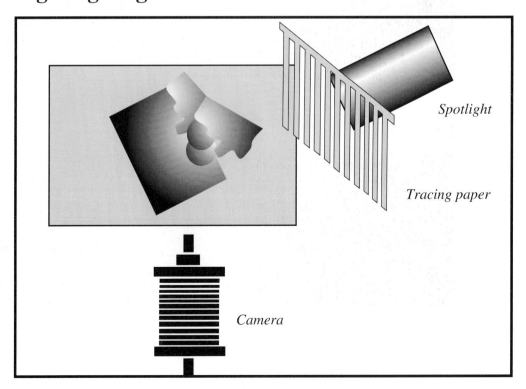

Spotlight

Tracing paper

Camera

Assignment 7 'Rusty items'

Lighting Direct spotlights plus selective fill.

Props Weathered, well worn and textured.

Background Use of light to create interest and separation of the subject from the background.

Exposure Adjusted reflected light meter reading of key light area.

Technique To enhance the degradation and degeneration of the subject by the use of sharp focus and lighting/subject contrast to create texture and age.

Polaroid 1

Place weathered and rusty textured items on a flat surface. Viewed from above, support a sheet of rusty corrugated iron with an irregular hole at its centre approximately 30cm above this surface. Aim a spotlight at low angle across the surface of the corrugated iron. Adjust the angle and intensity of the light to achieve maximum texture. Ensure that no light falls on the lower surface and subject matter. Take and note a reflected light meter reading of the light falling on an area reflecting approximately the same amount of light as an 18% grey card.

Polaroid 2

Turn off the first spotlight. Using a second spotlight, also at a low angle, light the lower surface and subject matter in such a way as to create long shadows and detailed texture. Adjust the angle, direction and intensity to achieve the most effective design and composition. Ensure that no light from the second spotlight falls on the top surface of the corrugated iron.

Polaroid 3

Turn on the first spotlight, turn off the second. Take a reflected light meter reading of the lower surface from an area reflecting approximately the same amount of light as an 18% grey card. Compare this reading with that noted in Polaroid 1. To increase the illusion of depth within the image adjust the amount of light on the top surface to approximately half to one stop more light than the lower surface. Turn on the second spotlight and adjust accordingly.

Lighting diagram

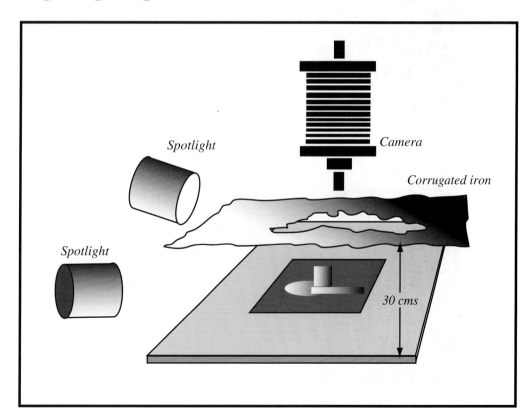

Assignment 8 'Black and White'

Lighting Diffuse or reflected light with minimal shadows. Direct spotlight with some degree of diffusion for detail in black subject matter.

Props Black and white.

Background Black and/or white, possibly created by the use of light.

Exposure Interpretation of reflected meter reading from black and white subject.

Technique To render true black and white on colour emulsion, with maximum detail in both.

Polaroid 1

Place selected props on a flat table top surface. Position to form an acceptable composition. As viewed from the camera place a spotlight behind and to the right of the subject. Centre the light on full spot on the top surface of the iron. Adjust the direction and intensity (flood or spot) to achieve maximum texture across the surface of the shirt and shadows with almost no detail forward of the iron. This will give detail across the top surface of the iron but make the shirt look very coarse.

Polaroid 2

Support a piece of tracing paper or other suitable diffusion material between the spotlight and the subject from just above the camera to the back edge of the framed area as seen in the viewfinder. This will reduce the intensity of the shadow forward of the iron and create a 'softer' look to the shirt material. Experiment with moving the tracing paper closer to or further away from the subject to achieve the desired degree of texture and shadow detail. This will have the effect of creating the quality of light suitable for the shirt but at the cost of losing some detail across the top of the iron. Turn off the first spotlight

Polaroid 3

Place a second spotlight slightly forward and directly above the iron. Position as close as possible to the tracing paper, switch on and turn to full spot. Reduce the amount of light spreading across the shirt by closing the barndoors until the concentration of light is falling on the top surface and leading side of the iron. This increases detail in the iron without greatly affecting the shirt. Take and note an incident reading, from the subject, of the second spotlight. Turn off the second light and turn on the first. Take an incident reading, from the subject, of the first light. Adjust the lights so that a reading of the second light is one stop more light than the first. Turn on both lights and take a reflected reading of the shirt. Depending on the actual shade of white increase the exposure by two stops to render the shirt white.

Lighting diagram

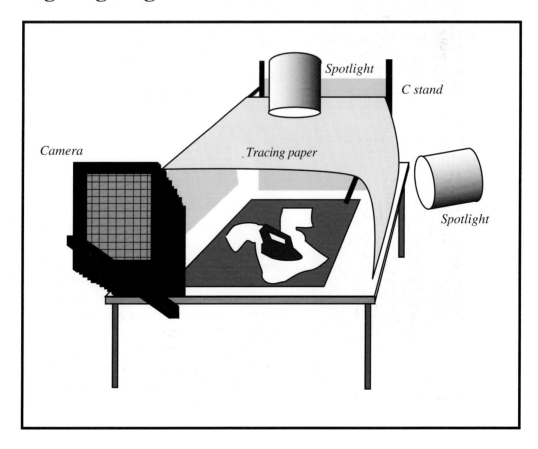

Assignment 9 'Cutlery'

Lighting Graduated diffuse lighting.

Props Reflective and metallic.

Background Complementary tonal range.

Exposure Incident or reflected light meter reading of 18% grey card.

Technique To reflect graduated light into the subject to form shape, and to reduce imperfections in reflective metal surfaces.

Polaroid 1

Place selected cutlery on a piece of translucent white perspex. Position subject and camera to obtain a satisfactory composition. Attach a large piece of tracing paper to the back edge of the perspex and to a c-stand above the front of the camera. This should create a 'tent' of tracing paper that completely covers the subject. Place a spotlight from behind and above the tracing paper. Centre the light on full spot in the centre of the paper. Moving the centre of the spot towards the front (camera) of the trace will create a graduation of light reflecting in the subject from white in the foreground through grey to almost black in the background. Moving the centre of the spot towards the back of the trace will achieve the opposite effect. Experiment with position and intensity (full spot through to full flood) until the desired effect is achieved.

Polaroid 2

Turn off the top light. Place a floodlight underneath the perspex. Position the light so the perspex is evenly lighted. Take a reflected meter reading of the surface and increase the aperture by three stops (e.g. f22 to f8) to render the surface white. Record this calculated exposure.

Polaroid 3

Turn on the top light. Place a strip of black paper approximately 3cms wide by the length of the tracing paper on top of the tracing paper from front to back. Position the black paper to create a reflective black edge along one side of the cutlery. Place an 18% grey card on top of the cutlery and take an incident reading of its surface. Depending upon the reflective values of the subject adjust your exposure accordingly. Increase the exposure by one to two stops for new cutlery or leave at MIE if old or tarnished. Choose an aperture that will give sharp focus over the cutlery and ensure the lighting ratio between the top light and the back light remains at 8:1. This can be achieved by increasing the light in relation to each other or by the separate exposure of each light source at different exposure times.

Lighting diagram

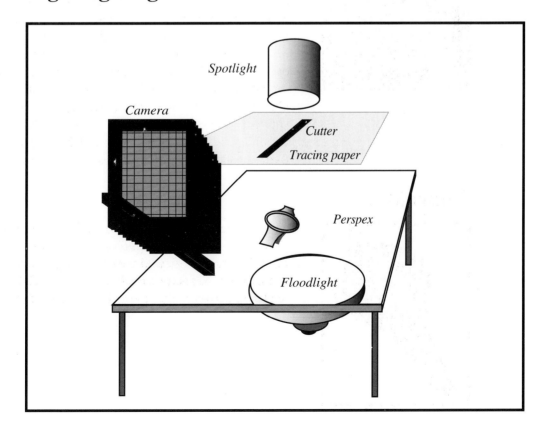

Gallery

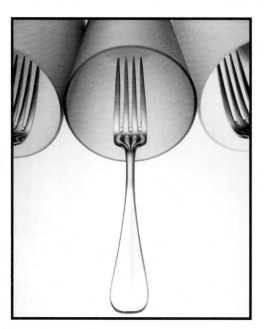

Naomi Yang *Tejal Shah*

Charanjeet Wadhwa

Assignments

Hugh Peachey

Aims

~ To develop and extend your knowledge and understanding of the application of studio lighting and camera technique.

~ To develop and extend your understanding of the practical use of light to create contrast, dimension, mood and to increase your creative ability to interpret a written brief with specific guidelines.

Objectives

~ **Research** - Through thorough pre-production ensure that all the requirements to produce the images are available in the right place at the right time.

~ **Discussion** - Exchange ideas and opinions with other students and lecturers relevant to the creative content of the assignments being completed.

~ **Practical work** - Produce colour transparencies to the highest standard that fulfil the criteria set down in the assignment information plus personal creative interpretation.

Introduction

The assignments in this study guide should only be attempted after successful completion of the all the assignments in **"Lighting Still Life"**. They are intended to test and understand the application of the lighting and camera techniques learned in the first series. Creative interpretation of the written brief is strongly encouraged. Assignments should be completed at an individual level in any order. Allowance should be made for the fact that each assignment may need shooting more than once before a satisfactory result is achieved. Group tutorials should be the forum where technique and creative interpretation are discussed amongst students and lecturers. Special attention should be taken of the medium in which the photograph is to be used. This will determine image format and in some cases composition. See **"Art Direction"**.

Samantha Souter *Joanne Gamvros*

It is imperative this series of images portray an understanding of what lighting and camera technique can achieve in changing the photographer's perception of the subject and previsualisation of the image. At this stage it is no longer acceptable to place a subject on a background, take a normal viewpoint and perspective and light for correct exposure. This is no different to documentation of the subject. As creative photographic illustrators much more is required. Experiment with viewpoint and lighting. Do not let reality get in the way of creative composition. Perspective, depth, dimension can all be altered to suit the design of the image. The camera will 'see' and record anything you want it to. This does not have to relate to human perception. Separate subjects from the background. Dispense with the concept of backgrounds altogether. The area behind and around the subject is only limited by your imagination. **Previsualise, experiment and create.**

1. Breakfast cereal

To illustrate the health giving and nutritional value of a cereal product, an advertising agency requires a photograph for a full page magazine ad. The approach should be in a contemporary style, with emphasis given to the premise that there is a healthy 'reward' for eating their cereal product. The packaging must be strongly featured, showing three sides and product name and logo clearly visible.

2. Clothing

A large clothing retailer requires a photograph for an in-store 'point of sale' poster. The photograph should be aimed at the youth market with the emphasis on 'lifestyle'. The shot must have a point of view of 45 degrees to the subject. Use should be made of selective focus to highlight detail and production identification.

3. Quality control

For the purpose of quality control, a large manufacturer requires a photograph depicting a close-up detail from their product range. The photograph should specifically show detail of manufacturing quality and/or design detail. The shot must have sharp focus throughout.

4. Paint

A quality paint manufacturer requires a photograph to launch a 'new' brand of paint. The manufacturer is the market leader in its field and is known for its high quality product. The brief is to show all or part of the packaging, with brand name and type of paint clearly visible. The manufacturer wants to show however some of the various colours available. The art director suggests that could best be illustrated by using various coloured paint swatches within the shot. The choice of colours to be used is to be determined by the photographer, taking into account film emulsions inability to sometimes faithfully record true colour. This is a critical element to the paint manufacturer.

5. Childhood memories

A weekend colour supplement requires an editorial photograph for a double page spread to complement an article on 'Childhood Memories'. The shot has to evoke nostalgia, warmth, security, tenderness and the fun of childhood days spent playing and enjoying treasured possessions. The result depends greatly on the interpretive use of light.

6. Glass

An international glass manufacturer requires a photograph for the cover of its Annual Report. As it has had a very successful financial year it has been suggested that a limited product range (various colours and sizes) been shown on a white background. One of their clear glass products filled with paper money should be featured in the foreground. The manufacturer (who has limited understanding of the photographic process) is emphatic that there are no specular highlights on the glass, the background be pure white, and the money clearly visible through the foreground product.

7. Industrial plastic

An industrial plastic manufacturer requires a photograph to be reproduced as a large mural for its head office reception area. Its main area of output is for the telecommunications industry. The client has requested that an abstract approach be taken to this large-scale visual. However emphasis should be placed on telephones and/or their related ancillary equipment.

8. Music

A record manufacturer has requested submissions to produce a photograph for a CD front insert cover. The photographer has been supplied with a demo CD in order that they may have a full understanding of the type of music involved (i.e. your choice). Props to be used at the photographer's discretion. As music is an emotional medium, the manufacturer has decided that any submission must attempt to portray the emotions felt by the photographer whilst listening to the featured track. At the same time it should be obvious the type of music it is (i.e. not a totally obscure image). This is an open brief, the only limitation being that there is movement during exposure of either object/s and/or light and/or camera.

9. Food

A publisher requires a double page photograph for an editorial article on a major processed food corporation. The product to be featured is from its line of packaged cheese. The concept behind the shot is that cheese has been a basic food source throughout history and will remain so into the future. The photographic approach should have strong appetite appeal and through the use of light and props convey a visual sense of the past or the future.

Gallery

Arthur Sikiotis

Tejal Shah

Ann Ouchterlony

Hugh Peachey

Gallery

Joanne Gamvros

Russell Shayer

Tejal Shah

Hugh Peachey

Lighting People

RMIT

Aims

~ To develop a knowledge and understanding of the application of studio lighting when photographing people.
~ To develop an understanding of the practical use of light to create tonality, dimension and mood.

Objectives

~ **Research** - Through thorough pre-production ensure that all the requirements to produce the images are available in the right place at the right time.
~ **Discussion** - Exchange ideas and opinions with other students and lecturers relevant to the assignments being completed.
~ **Practical work** - Produce colour tranparencies to the highest standard that fulfil the criteria set down in the assignment information.

Introduction

Many different styles of portraiture lighting have evolved since the invention of photography. The approaches that can be taken to portraiture, in fact to any genre of photography, are limited only by your imagination. The technical boundaries to photography are at the point of being almost non existent. To teach or learn portraiture lighting it is important to understand people and how to light the human form, and particularly the face. Portraiture relies heavily on the rapport that needs to be built up, sometimes in a very short period of time, between the photographer and the subject. Whether the photograph is successful or not depends entirely on the photographer being able to capture the essence of the person on film. It is therefore essential the photographer has a thorough understanding of technique and lighting to make it seem to the subject that the actual photographic process is a very minor part of the whole experience. Nothing will alienate the subject more than being confronted by equipment they are not used to and a photographer who appears not to have the situation under control. Confidence in your abilities and thorough understanding of your technique is the one way to inspire and relax the subject of your portrait.

High key - Gary Gross *Low key - RMIT*

There are three 'classical' approaches to portraiture. These are High Key, Low Key and Mid Key. Portraiture in these categories is recognised by the difference in the variation and extremes of the tonal range throughout the image. In its simplest form the difference between the three categories is best understood by comparing the portraiture to exposure. In a subject with average reflectance ratios, a mid key could be compared to correct exposure, low key to under exposure and high key to over exposure. It is important to remember that this is not how the result is achieved. With this visual in mind it will be easier to create the lighting required using lighting ratios coupled with exposure interpretation.

High key

In high key images light tones dominate. Dark tones are eliminated or reduced by careful selection of the tonal and subject brightness range of the subject matter. Soft diffused lighting from broad light sources are used to reduce all shadows. Backgrounds should be flooded with light and overexposed to reduce detail. Increasing exposure beyond 'normal' by up to two stops ensures that all the tones are predominantly light. Hard edges and fine detail can be reduced by the use of a soft focus filter. When using black and white film skin imperfections can be reduced by using an orange or red filter. A bright background placed close to the subject will also soften their outline. Even though the quantity of light used to create high key is large the actual lighting ratio is small (1:1).

Low key

In a low key image dark tones dominate the photograph. Bright highlights punctuate the shadow areas creating the characteristic mood of a low key image. The position of the key light source for a typical low key image is behind the subject (or behind and to one side). This creates deep shadows. The strong backlight creates specular highlights around the rim of the subject. Selective fill light is then used to increase the subject brightness range to a level that will give an average exposure. The decision concerning appropriate exposure usually centres around how far the exposure can be reduced before the highlights appear dull (underexposed). The shadow areas are usually devoid of detail when this action is taken unless a certain amount of fill is provided. The lighting ratio is relatively high compared to high key (8:1).

Mid key

In a mid key image there is no dominant tone. They are all relatively equal. There are no deep shadows and no extreme highlights. The lighting used is a mixture of both high key and low key (direct and diffuse). Back lighting can be used to create rim light around the subject and fill light to reduce and control shadow areas. An increase in 'normal' exposure of one stop more light would usually be required to achieve a mid key result. The lighting ratio is less than low key (4:1).

Activity 1

Through research of personal and library resources locate the following images.

Low Key - 'Churchill'. 1941. Yousuf Karsh.
Mid Key - 'Mother and daughter, Cuzco, Peru'. 1948. Irving Penn.

Find an example from these sources of a high key portrait.
Study the images and draw a considered lighting diagram for each.
Photocopy these and other examples and compile in your Visual Diary.
Discuss with lecturer and other students the various portraits collected.

Assignment 1 'High key'

Image with a predominance of light tones. The result is achieved using a combination of diffuse even lighting, overexposure, selective filtration and some diffusion. This technique is artificially created and is often used in Glamour, Fashion and Child portraiture. The lighting technique creates a shadowless, soft rendering of the face. The final image will primarily consist of dominant whites, some defining greys and few deep shadows. Make-up is used to retain detail in the lips and eyes and filtration to reduce skin imperfections.

Polaroid 1

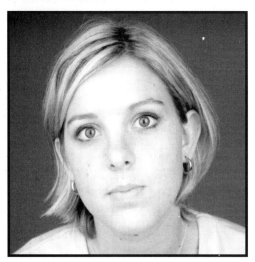

Place the subject approximately two metres from a white background. Soft diffuse light sources (reflective flash umbrellas) are placed on either side of the subject. Place large white reflectors next to each light at 90 degrees to the subject. This will reflect all light from the two front light sources back onto the subject. Take and record an incident meter reading from the subject of each light source ensuring there is a half stop difference between them. Viewed from camera the left light should read f11, the right f8.5 at 1/250 second.

Polaroid 2

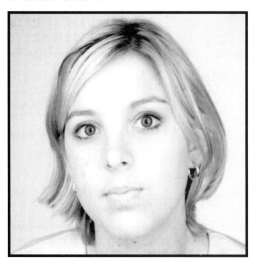

Place two soft diffuse light sources (reflective flash umbrellas) in front of the white background, behind and to the side of the subject. Angle the lights at 45 degrees to the background. Place black cutters between the lights and the subject to reduce lens flare and to eliminate any direct light falling on the subject. Take and record an incident light meter reading of each light source from the white background ensuring that they are equal. The reading should be f11 at 1/250 second. This gives a lighting ratio of 1:1 between the foreground and the background.

Polaroid 3

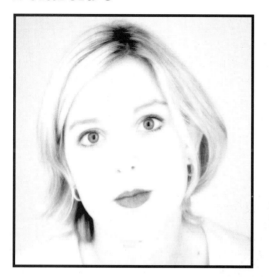

Place a white reflector underneath the face of the subject. This will reduce any shadows under the chin, nose and eyebrows. Apply make-up to the eyes (eye liner), lips (dark red lipstick) and foundation to the face. Attach a diffusion filter to the lens. Take an incident meter reading from the subject to the camera and overexpose by two stops. This will give a exposure of f5.6 at 1/250 second. A red filter (plus appropriate exposure compensation) can be added at this stage if using black and white film.

Lighting diagram

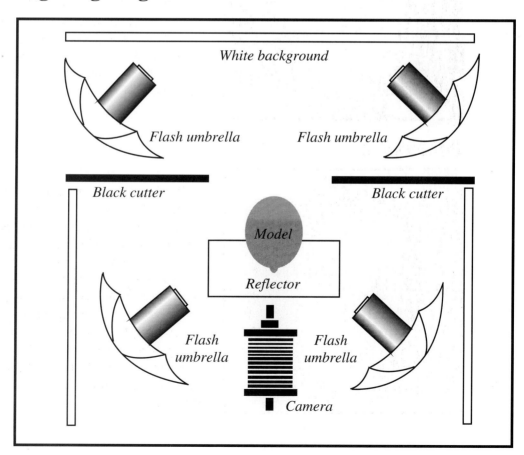

Assignment 1 'Low key'

Image with a predominance of rich dark tones with selected specular highlight areas. The result is achieved by a progressive build-up of light across the face to maximise texture, tonality and drama. This requires predominantly direct specular light sources. The nature and quality of this light must be precisely set and varies for each subject, dependant on face shape and form. The spotlights must be placed in relation to camera and subject position so that the angle of incidence equals the angle of reflection in order to achieve specular highlights across areas of the face. See **"Light"**.

Polaroid 1

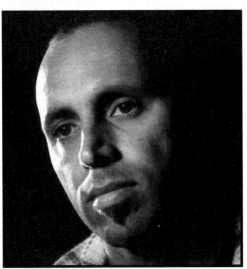

Place the subject approximately two metres from a black background. As viewed from the camera, position a spotlight behind and to the left side of the subject. Adjust the spotlight to achieve an incident meter reading of the light from the subject of f8 at 1/30 second. Position a floodlight in front of and to the left side of the subject. Adjust the floodlight to achieve an incident meter reading of the light from the subject to equal that of the spotlight. Place a black cutter between the two lights to reduce lens flare. Record incident light meter readings.

Polaroid 2

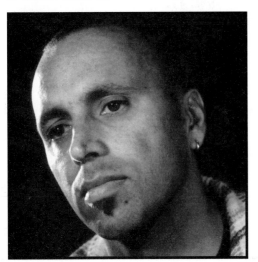

Place a second floodlight in front of and to the right side of the subject. Adjust the floodlight until an incident light meter reading of the light from the subject of f5.6 at 1/30 second is obtained. This will provide fill light to the camera right side of the face and reduce nose and chin shadows. This will be a lighting ratio of 2:1 between the left and right sides of the face. Record incident light meter reading.

Polaroid 3

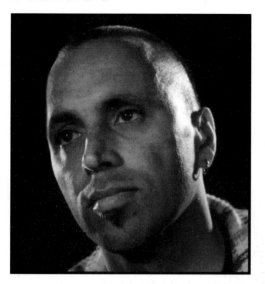

Position a second spotlight behind and to the camera right side of the subject. Adjust the light to achieve maximum specular reflection to the camera right side of the face. Take an incident light meter reading of the spotlight from the subject to achieve a reading of f8 at 1/30 second. Place a black cutter between the lights on the right side of the subject to reduce lens flare. Take a reflected light meter reading of the camera left side of the face ensuring that no light from the rear spot lights affect the reading. This reading will be 'correct' for exposure. The shadows will under expose and the highlights over expose.

Lighting diagram

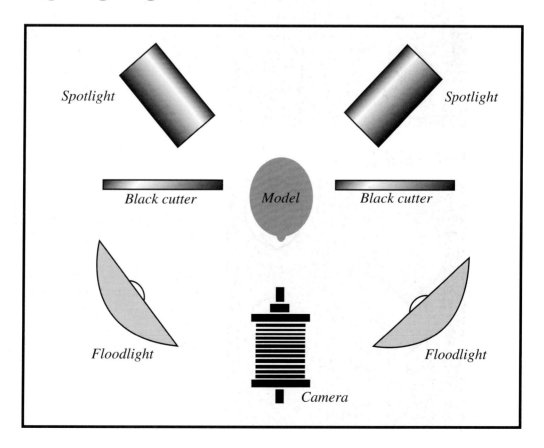

Assignment 3 'Mid key'

Image with a predominance of average tones, with no extreme of highlights or shadows. The result is achieved using large soft very diffuse even lighting, selective fill and over exposure by one stop to obtain correct skin tones. This is by far the most commonly used form of portraiture lighting. It is relatively simple to set up compared to high and low key lighting and will produce good results with most subjects. It does however lack drama and mood and would not enhance subjects with great physical character or delicacy of form.

Polaroid 1

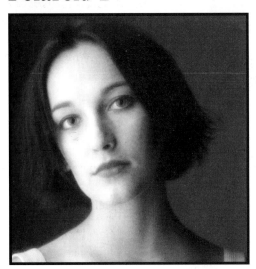

Place the subject approximately two metres from a large diffusion screen (background). As viewed from the camera place a soft diffuse light source (flash soft box) in front of and to the left of the subject. Place a diffusion screen larger than the light source between the light source and the subject. The screen should be approximately one third of the distance from the light to the subject. Take an incident light meter reading from the subject to the camera. A typical reading would be f11 at 1/250 second. The background remains unlighted.

Polaroid 2

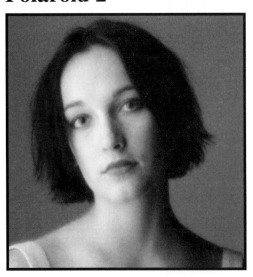

Place a large (2m x 3m) white reflector in front of and to the camera right side of the subject. This will reflect light from the key light source back onto the right side of the subject. Adjust the distance of the reflector from the subject until an incident light meter reading from the subject to the reflector is one stop less than that obtained from the key light. This should be f8 at 1/250 second. This is a lighting ratio of 2:1 between the left and right sides of the face and when used for exposure will overexpose the left side of the face to reduce any skin imperfections.

Polaroid 3

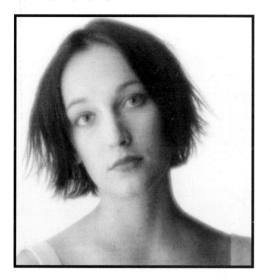

Place behind the large diffusion screen in the background a large diffuse light source (flash soft box). Direct the light through the diffusion screen straight back at the camera. Adjust the light source so that an incident light meter reading taken from the subject to the diffusion screen in the background is two stops more than the incident reading of the subject to camera (f8 at 1/250 second). This background reading should be f16 at 1/250 second. If the subject exposure is set to f8 at 1/250 second the background will appear white.

Lighting diagram

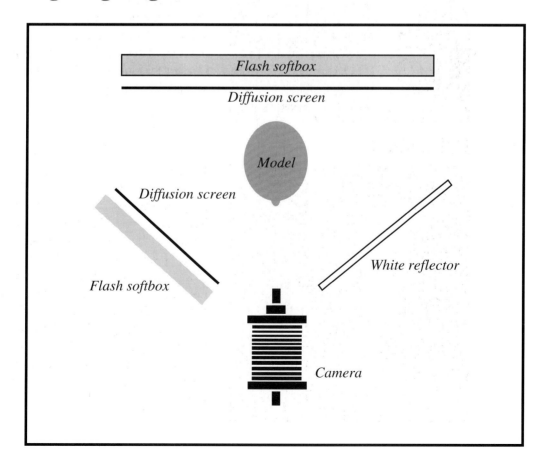

Pose

Mid key - Viva Partos

Making people look at ease in front of the camera is as much a skill to be learnt as the skill required to light and correctly expose. For some photographers the skill is acquired easily. For most it will take time and patience. It is important you not only make the subject feel at ease but also you are relaxed, and confident of your ability to control a 'people session'. There are defined and classical approaches to 'compositional pose' that have evolved throughout the history of painting and photography. These are well documented and relatively easy to reproduce. It is much harder to make people look 'real'. The best equipment and lighting will not make the subject come alive. Only the rapport between the photographer and their subject can make that happen. If the subject looks awkward or ill at ease do not shoot. Wait. Walk away from the camera but continue to talk to your subject. Attach a long cable release or remote firing device to the camera. This will enable you to make exposures away from the camera and in mid conversation. The camera is often intimidating enough without the photographer standing behind it. Being relaxed can be infectious. Start with photographing people you know. As your confidence grows photograph people you don't know. Professional 'models' are trained to perform easily for the camera. Documentary and domestic subjects with little or no experience will have greater difficulty.

Gallery

Dianna Snape

Gary Gross

Russell Shayer

Thuy Vuy

Gallery

Janette Pitruzzello

Gary Gross

Viva Partos

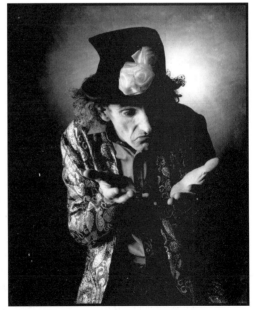

Gary Gross

Glossary

1K	1,000 watts, measure of light output.
2K	2,000 watts, measure of light output.
5K	5,000 watts, measure of light output.
10K	10,000 watts, measure of light output.
12K	12,000 watts, measure of light output.
120	Film format.
2 1/4	2 1/4 x 2 1/4 inches camera format.
35mm	Camera and film format (24 x 36mm).
500W	500 watts, measure of output.
5 x 4	5 x 4 inches, camera and film format.
6 x 4.5	6 x 4.5 cm camera format.
6 x 6	6 x 6 cm camera format.
6 x 7	6 x 7 cm camera format.
6 x 8	6 x 8 cm camera format.
6 x 9	6 x 9 cm camera format.
10 x 8	10 x 8 inches camera and film format.
80A	Conversion filter, daylight film to 3200K light source.
80B	Conversion filter, daylight film to 3400K light source.
85B	Conversion filter, tungsten film to 5500K light source.
AC discharge	5600K continuous light source.
Ambient	Available or existing light.
Ambrotype	Popular portrait medium of the 1850s.
Analyse	To examine in detail.
Analysis	Results of examination in detail.
Aperture	Lens opening controlling intensity of light entering camera.
Arri 650W	Arriflex 650 watt light source (3200K).
ASA	Film speed rating - American Standards Association.
Asymmetrical	Unbalanced.
Autofocus	Automatic focusing system, mainly small format cameras.
Available	Ambient or existing light.
B	Shutter speed setting for exposures in excess of one second.
B/g	Background.
Background	Area behind main subject matter.
Backlight	Light source directed at the subject from behind.
Balance	Relationship between elements within the frame.
Barn doors	Metal shutters attached to light source.
Bellows	Light-proof material between front and rear standards.
Bellows extension	When length of bellows exceeds focal length of lens.
Bellows formula	Mathematical process to allow for loss of light.

Bleed	Allowance within full image area for printing irregularities.
Blurred	Unsharp image, caused by inaccurate focus, shallow depth of field, slow shutter speed, camera vibration or subject movement.
Body copy	Written word, main content of advertisement.
Bounce	Reflected light
Bracketing	Over and under exposure either side of meter-indicated exposure.
C stands	Vertical stand with adjustable arm.
C41	Negative film process.
Cable release	Device to release shutter, reduces camera vibration.
Calotype	First viable negative/positive process.
Camera	Image capturing device.
Camera shake	Blurred image caused by camera vibration during exposure.
Close down	Decrease in aperture size.
Closest point of focus	Minimum distance at which sharp focus is obtained.
Colour temperature	Measure of the relationship between light source and film.
Colour correction	Use of filtration to balance film to light source.
Compensation	Variation in exposure from MIE to obtain appropriate exposure.
Complementary	Visual - design improvement.
Complementary	Colour - see primary and secondary.
Composition	Basis of visual design, arrangement of shape, line, tone and colour within the image area.
Compound	In lens design, indicating use of multiple optical elements.
Concept	Idea or meaning.
Contemporary	Of the present.
Context	Circumstances relevant to subject under consideration.
Contrast	Difference between highlights and shadows.
Cord	Electrical lead.
Covering power	Ability of a lens to cover film format with an image.
Cropping	Alter image format to enhance composition.
Cut off	Loss of image due to camera aberrations.
Cutter	Device used to control spread and direction of light.
Cyclorama	Visually seamless studio.
Dark slide	Cut film holder.
Dark-cloth	Material used to give a clearer image on ground glass.
Daylight	5500K.
Dedicated flash	Flash regulated by camera's exposure meter.
Dense	Over exposed negative, under exposed positive.
Density	Measure of the opacity of tone on a negative.
Depth of field	Area of sharpness variable by aperture or focal length.
Depth of focus	Distance through which the film plane moves without losing focus.
Design	Basis of visual composition.

Diagonal	A line neither horizontal nor vertical.
Diaphragm	Aperture.
Differential focusing	Use of focus to highlight subject areas.
Diffuse	Dispersion of light (spread out) and not focused.
Diffuser	Material used to disperse light.
Digital	Images recorded in the form of binary numbers.
Digital image	Computer generated image created with pixels, not film.
DIN	Film speed rating - Deutsche Industrie Norm.
Direct light	Light direct from source to subject without interference.
Dioptres	Close-up lenses.
Distortion	Lens aberration or apparent change in perspective.
Double dark slide	Cut film holder.
Dynamic	Visual energy.
DX coding	Bar coded film rating.
E6	Transparency film process.
Ecu	Extreme close up.
Electronic flash	Mobile 5800K light source of high intensity and short duration.
Emulsion	Light sensitive coating on film or paper.
Equivalent	Combinations of aperture and time, producing equal exposure.
Evaluate	Estimate the value or quality of a piece of work.
Expansion	Manipulating the separation of zones in B & W processing.
Exposure	Combined effect of intensity and duration of light on light sensitive material.
Exposure factor	Indication of the increase in light required to obtain correct exposure.
Exposure meter	Device for the measurement of light.
Exposure value	Numerical values used in exposure evaluation without reference to aperture or time.
Extreme contrast	Subject brightness range that exceeds the film's ability to record all detail.
EV	Numerical values used in exposure evaluation without reference to aperture or time.
F-number	Numerical system indicating aperture diameter.
F-stop	Numerical system indicating aperture diameter.
Fall	A movement on large format camera front and rear standards.
Fast film	Film with high ISO, can be used with low light levels.
Field of view	Area visible through the camera's viewing system.
Figure and ground	Relationship between subject and background.
Fill	Use of light to increase detail in shadow area.
Film	Imaging medium.
Film speed	Rating of film's sensitivity to light.
Filter	Optical device used to modify transmitted light.

Filter factor	Number indicating the effect of the filter's density on exposure.
Flare	Unwanted light entering the camera and falling on film plane.
Flash	Mobile 5800K light source, high intensity, short duration.
Floodlight	Diffuse tungsten light source.
Focal	Term used to describe optical situations.
Focal length	Lens to image distance when focused at infinity.
Focal plane	Where the film will receive exposure.
Focal plane shutter	Shutter mechanism next to film plane.
Focal point	Point of focus at the film plane or point of interest in the image.
Focusing	Creating a sharp image by adjustment of the lens to film distance.
Fog	Effect of light upon unexposed film.
Fogging	Effect of light upon unexposed film.
Foreground	Area in front of subject matter.
Format	Camera size, image area or orientation of camera.
Frame	Boundary of composed area.
Fresnel	Glass lens used in spotlight.
Front light	Light from camera to subject.
Front standard	Front section of large format camera.
Gels	Colour filters used on light sources.
Genre	Style or category of photography.
Gobos	Shaped cutters placed in front of light source.
Golden section	Classical method of composition.
Grey card	Contrast and exposure reference, reflects 18% of light.
Ground glass	Viewing and focusing screen of large format camera.
Halftone	Commercial printing process, reproduces tone using a pattern of dots printed by offset litho.
Hard light	Directional light with defined shadows.
Harsh light	Directional light with defined shadows.
High key	Dominant light tones and highlight densities.
Highlight	Area of subject giving highest exposure value.
HMI	Trademark of Osram. AC discharge lamp, 5600K.
Hot shoe	Plug in socket for on camera flash.
Hyperfocal distance	Nearest distance in focus when lens is set to infinity.
Incandescent	Tungsten light source.
Incident	Light meter reading from subject to camera using a diffuser.
Infinity	Point of focus where bellows extension equals focal length.
Invercone	Trademark of Weston. Dome shaped diffuser used for incident light meter readings.
Inverse square law	Mathematical formula for measuring the fall-off (reduced intensity) of light over a given distance.
Iris	Aperture/diaphragm.

ISO	Film speed rating - International Standards Organisation.
Keylight	Main light source relative to lighting ratio.
Laboratory	Film processing facility.
Landscape	Horizontal format.
Large format	5 x 4 inch camera, 10 x 8 inch camera.
Latitude	Film's ability to record the brightness range of a subject.
Lens	Optical device used to bring an image to focus at the film plane.
Lens angle	Angle of lens to subject.
Lens cut-off	Inadequate covering power.
Lens hood	Device to stop excess light entering the lens.
Light	The essence of photography.
Lightbox	Transparency viewing system.
Light meter	Device for the measurement of light.
Lighting contrast	Difference between highlights and shadows.
Lighting grid	Studio overhead lighting system.
Lighting ratio	Balance and relationship between light falling on subject.
Long lens	Lens with a reduced field of view compared to a normal.
Loupe	Viewing lens.
Low key	Dominant shadow densities.
Luminance range	Range of light intensity falling on subject.
M	Flash synchronisation setting for flash bulbs.
Macro	Extreme close up.
Maximum aperture	Largest lens opening, smallest f-stop.
Medium format	6 x 7, 6 x 6, 6 x 4.5 cm.
Meter	Light meter.
MIE	Meter indicated exposure.
Minimum aperture	Smallest lens opening, largest f-stop.
Monorail	Support mechanism for large format camera.
Multiple exposure	More than one exposure on the same piece of film.
ND	Neutral density filter.
Negative	Film medium with reversed tones.
Negatives	Exposed, processed negative film.
Neutral density	Filter to reduce exposure without affecting colour.
Non-cord	Flash not requiring direct connection to shutter.
Normal lens	Angle of view approximately equivalent to the eye.
Objective	Factual and non-subjective analysis of information.
Opaque	Does not transmit light.
Open up	Increase lens aperture size.
Orthochromatic	Film which is only sensitive to blue and green light.

Overall focus	Image where everything appears sharp.
Over development	When manufacturer's processing recommendations have been exceeded.
Over exposure	Exposure greater than meter indicated exposure.
Panning	Camera follows moving subject during exposure.
Panchromatic	Film which is sensitive to blue, green and red light.
Perspective	The illusion of depth and distance in two dimensions. The relationship between near and far imaged objects.
Photograph	Image created by the action of light and chemistry.
Photoflood	3400K tungsten light source.
Plane	Focal plane.
P.o.v.	Point of view.
Polariser	Filter used to remove polarised light.
Portrait	Type of photograph or vertical format.
Positive	Transparency.
Preview	Observing image at exposure aperture.
Previsualise	Ability to imagine the result.
Primary	The colours, blue, green and red.
Process	Development of exposed film.
Pull	Under processing of film.
Push	Over processing of film.
QI	Quartz iodine light source (tungsten halogen).
Rear standard	Rear section of large format camera.
Reciprocity failure	Inability of film to behave predictably at exposure extremes.
Reflected	Light coming from a reflective surface.
Reflectance	Amount of light from a reflective surface.
Reflectance range	Subject contrast measured in even light.
Reflected light	Amount of light from a reflective surface.
Reflection	Specular image from a reflective surface.
Reflector	Material used to reflect light.
Refraction	Deviation of light.
Resolution	Optical measure of definition, also called sharpness.
Reversal	Colour transparency film.
Rimlight	Outline around a subject created by a light source.
Rise	A movement on large format camera front and rear standard.
Rule of thirds	Division of the composition into three equal parts.
Saturation	Intensity or richness of colour.
SBR	Subject brightness range, a measurement of subject contrast.
Scale	Size relationship within subject matter.
Scrim	Diffusing material.

Secondary	Complementary to primary colours, yellow, magenta, cyan.
Selective focus	Use of focus and depth of field to emphasise subject areas.
Shadow	Unlighted area within the image.
Sharp	In focus.
Shutter	Device controlling the duration (time) of exposure.
Side light	Light from side of subject.
Shutter speed	Specific time selected for correct exposure.
Silhouette	Object with no detail against background with detail.
Slave	Remote firing system for multiple flash heads.
Slide	Transparency usually 24 x 36mm.
SLR	Single lens reflex camera, viewfinder image is identical to film image.
Slow film	Low film speed rating.
Small format	35mm.
Snoot	Cone shaped device to control the spread of light.
Softbox	Heavily diffuse light source.
Soft-light	Diffuse light source with ill defined shadows.
Specular	Highly reflective surfaces.
Speed	ISO rating, exposure time relative to shutter speed.
Spot meter	Reflective light meter capable of reading small selected areas.
Spotlight	Light source controlled by optical manipulation of a focusing lens.
Standard lens	Perspective and angle of view equivalent to the eye.
Stock	Chosen film emulsion.
Stop	Selected lens aperture relative to exposure.
Stop down	Decrease in aperture size.
Strobe	5800K light source.
Studio	Photographic workplace.
Subject	Main emphasis within image area.
Subject matter	Main emphasis within image area.
Subject reflectance	Amount of light reflected from the subject.
Subjective	Interpretative and non-objective analysis of information.
Swing	A movement on large format front or rear standards.
Symmetrical	Image balance and visual harmony.
Sync.	Flash sychronisation.
Sync. lead	Cable used to synchronise flash.
Sync. speed	Shutter speed designated to flash.
T	Shutter speed setting for exposures in excess of 1 second.
Text	Printed word.
Thin	Over exposed positive, under exposed negative.
TTL	Through the lens metering system.
T-stop	Calibration relating to light actually transmitted by a lens.

Tilt	A movement on large format front or rear standards.
Time	Shutter speed, measure of duration of light.
Time exposure	Exposure greater than 1 second.
Tonal range	Difference between highlights and shadows.
Tone	A tint of colour or shade of grey.
Trace	Material used to diffuse light.
Transmitted light	Light that passes through a medium.
Transparency	Positive film image.
Transparent	Allowing light to pass through.
Tripod	Camera support.
Tripod clamp	Device used to connect camera to tripod.
TTL	Through the lens light metering system.
Tungsten	3200K light source.
Type face	Size and style of type.
Typography	Selection of type face.
Under development	When manufacturer's processing recommendations have been reduced.
Vertical	At right angles to the horizontal plane.
Viewpoint	Camera to subject position.
Visualise	Ability to exercise visual imagination.
Wide angle	Lens with a greater field of view than normal.
X	Synchronisation setting for electronic flash.
X - sync.	Synchronisation setting for electronic flash.
Zone	Exposure system related to tonal values.

Other Titles in the Series

Location Photography: Essential Skills
Mark Galer

This provides essential skills for photographers using 35mm SLR and medium format cameras working with both ambient and introduced light. Through a series of practical exercises the photographer is shown the techniques and design elements required to be able to communicate clearly and creatively. The basic essentials are described, from exposure, to framing the image and how to work with light and contrast.

1999 • 192 pp • 246x189 mm • Paperback • 0 240 51548 X

Photographic Lighting: Essential Skills
John Child and Mark Galer

This covers information that is essential for photographers to understand when working with light. Through a series of practical exercises, the student photographer is shown how to overcome the limitations of equipment and film emulsion, to achieve creative and professional results. With theory kept to a minimum, this book shows how to tackle difficult lighting conditions and manipulate light for mood and atmosphere using basic and advanced metering techniques.

!999 • 160 pp • 246x189 mm • Paperback • 0 240 51549 8

Basic Photography
Michael Langford

Basic Photography is an international bestseller with a
long established reputation as the introductory textbook
for photography. Initially published over thirty years
ago the book has been re-written and revised regularly,
and translated into four foreign language editions. It
remains a classic reference source for students and newcomers to
photography of all ages.

1997 • 320pp • 246 x 189 mm • Paperback • 0 240 51485 8

Advanced Photography
Michael Langford

This is a practical book for students and serious
enthusiasts who wish to achieve more professional
looking results. From choosing lenses and camera
equipment, to film types and technical data, lighting and
tone control, processing management and colour
printing; the book offers technical solutions and practical
advice on all aspects of professional photography. It includes not just the latest
camera equipment and films, but explains how new digital methods can be
used alongside silver halide systems – allowing the reader to benefit from the
best practical features of each.

1998 • 320pp • 246 x 189 mm • Paperback • 0 240 51486 6

Starting Photography
Michael Langford

This is a practical book for the absolute beginner. It shows you how to compose your pictures for more visual effect, understand the camera controls that will allow you more creative freedom, tackle different subjects and difficult lighting conditions, photograph in a studio and process and print your own pictures in the darkroom. Each chapter is fully illustrated with colour examples and suggestions for practical exercises allow you to practice and explore different effects.

1999 • 192pp • 234 x 156 mm • Paperback • 0 240 51484 X

Story of Photography
Michael Langford

From works of art to hard-hitting photojournalism, photography continues to challenge and enhance our perception of the world. This book shows how it became possible: from the early experiments with light, to sophisticated camera equipment and the stunning work of famous photographers. Illustrated throughout, the reader is taken on a fascinating photographic tour through history, whether you are a student or dedicated enthusiast, this book will further your understanding of photography.

1998 • 224pp • 246 x 189 mm • Paperback • 0 240 51483 1

Professional Photography Series

Professional Architectural Photography
Michael Harris

As a perfectionist art form, architectural photography is a methodical process demanding patience and clinical precision from its practitioners, combined with an experienced understanding of the potential and effects of natural light. Packed with detailed information plus first-hand tips and advice, this is a complete introduction for any aspiring architectural photographer, or a practicing professional needing to brush up on skill and knowledge.

1998 • 192pp • 246 x 189 mm • Paperback • 0 240 51532 3

Professional Interior Photography
Michael Harris

Professional Interior Photography is a complete guide to the practice and art of the interior photographer. It guides you through the vast choice of equipment and materials available, combines the theory of lighting and composition with practical tips and suggestions for overcoming day-to-day problems, and offers useful advice on presenting and storing images, business skills and administration.

1998 • 192pp • 246 x 189 mm • Paperback • 0 240 51475 0

Professional Photography Series

Professional Press, Editorial and PR Photography
Jon Tarrant

Editorial, press and PR photographers need to be able to take a range of interesting and informative photographs. Success requires not just individual flair and skill, but an ability to market those talents in order to win space in publications. This book is packed with hints, tips and first-hand advice on the day-to-day running of a business, the equipment you need and how to organise your finances. Advice on the best way to present your portfolio and how to deal with clients and work to a brief is also given.

1998 • 192pp • 246 x 189 mm • Paperback • 0 240 51520 X

Professional Nature Photography
Nigel Hicks

Based on the author's own experience of running a successful nature photography business, this book offers a unique insight into the essential tools and techniques: from the equipment you need, to researching and finding new clients, negotiating contracts, managing finance, working to a brief and an understanding of professional ethics. It also includes an overview of specialist skills, such as how to read difficult lighting conditions, shooting from a hide, stalking animals, photographing captive animals, photographing plants and underwater photography.

1999 • 192pp • 246 x 189 mm • Paperback • 0 240 51521 8